WO

T

JOHN CONSTABLE

The Man and his Art

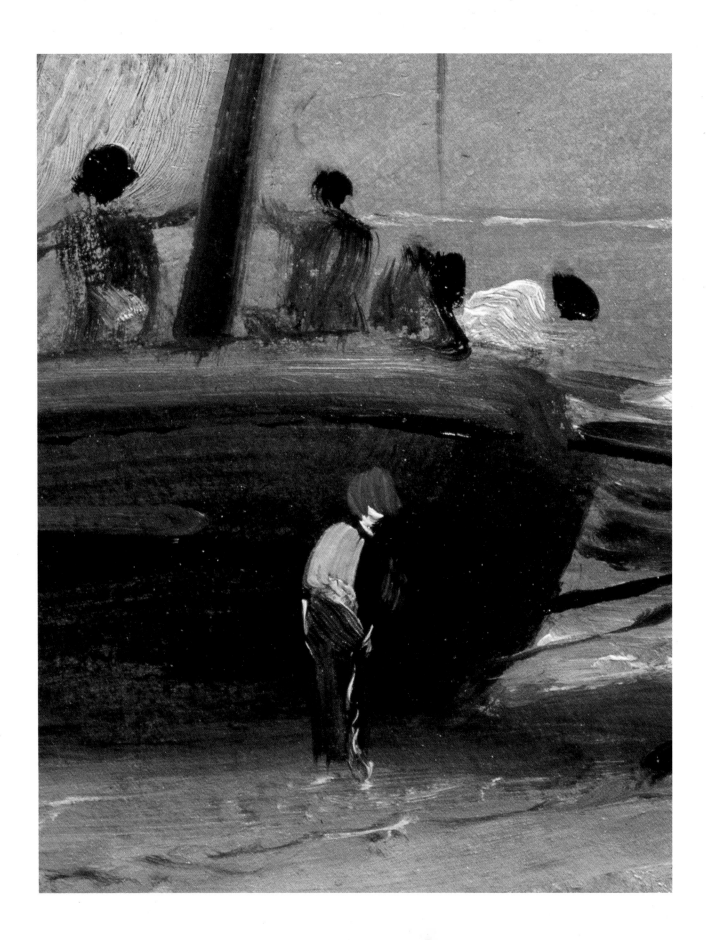

JOHN CONSTABLE

The Man and his Art

Ronald Parkinson

V&A PUBLICATIONS

First published by V&A Publications, 1998

V&A Publications
160 Brompton Road, London SW3 1HW

© The Board of Trustees of the Victoria and
Albert Museum 1998

Ronald Parkinson asserts his moral right to
be identified as the author of this book

Designed by James Shurmer

ISBN 185177243X

A catalogue record for this book is available
from the British Library

Printed in Singapore

Every effort has been made to seek permission
to reproduce those images whose copyright
does not reside with the V&A, and we are
grateful to the individuals and institutions
who have assisted in this task. Any omissions
are entirely unintentional, and the details
should be addressed to the publishers.

JACKET ILLUSTRATIONS

Front: Detail from plate 63: *Salisbury
Cathedral from the Bishop's Grounds* 1823.

Back: Detail from plate 44: *Weymouth Bay
(Bowleaze Cove)*, 1816.

FRONTISPIECE

Detail from plate 76: *Brighton Beach, with
fishing boat and crew*, 1824.

CONTENTS

ACKNOWLEDGEMENTS

I would like to thank my hosts in Suffolk, Jon and
Maureen Amsden, and John and Jo-Anne Rutter,
Nicholas Savage of the Royal Academy Library, Leslie Parris
of the Tate Gallery, Isabel Sinden, Jo Wallace and Nick Wise
of the V&A Picture Library, Mary Butler and Miranda
Harrison of V&A Publications, my editor Henrietta
Wilkinson, and – as always – my colleagues in the
Department of Prints, Drawings and Paintings for their
support and encouragement: Susan Lambert, Sharon Fermor,
Katherine Coombs and Janet Skidmore.

This book is dedicated to my greatest friend, Joe Wiebkin.

CHRONOLOGY OF CONSTABLE'S LIFE

1776 Born 11 June at East Bergholt, Suffolk.

1792 Works in the family business, the trade and transport of corn and coal.

1794 Goes on a sketching tour of Norfolk.

1795 Meets the patron and amateur painter, Sir George Beaumont.

1796 Meets John Fisher, who later became Bishop of Salisbury.

1799 Gets permission from his parents to study art in London; gives a letter of introduction to Joseph Farington R.A., shows him some sketches, and is admitted as a Probationer in the Royal Academy Schools.

1801 His father consents to 'his practising in order to profess Painting, but thinks he is pursuing a shadow – wishes to see him employed'. Makes a sketching tour of Derbyshire.

1802 Exhibits his first painting at the R.A. summer exhibition, but writes to his friend Dunthorne in May that 'I shall shortly return to Bergholt where I shall make some laborious studies from nature... There is little or nothing in the exhibition worth looking up to – there is room enough for a natural painter'.

1806 Sketching tour of the Lake District.

1809 Meets and falls in love with Maria Bicknell, daughter of an eminent solicitor.

1810 First unsuccessful application for the Associateship of the R.A.

1811 First visit to Salisbury; meets the Bishop's nephew, Archdeacon John Fisher, who becomes a life-long friend.

1813 Sits next to Turner at the annual R.A. dinner: 'he is uncouth but has a wonderful range of mind'.

1816 Marries Maria in St Martin's-in-the-Fields, London; honeymoon at Osmington, near Weymouth, Dorset.

1817 For the first time receives some votes in the R.A. Associateship elections, but is not elected.

1819 Exhibits *The White Horse*, the first of the great six-foot canal scenes, at the R.A: the younger John Fisher buys it for 100 guineas, and Constable is finally elected an Associate by one vote. He rents Albion Cottage, Upper Heath, Hampstead, from August to October.

1820 Visits Stonehenge.

1821 Works on *The Hay Wain* for the R.A. summer exhibition.

1822 Birth of Isabel, the fourth of seven children, who gave the family collection of Constable's work to the V&A in 1888. He works on *Salisbury Cathedral from the Bishop's Grounds* for the 1823 R.A. exhibition.

1824 Visits Brighton for the sake of Maria's health; exhibits *The Hay Wain* at the Paris Salon, where it is much admired by young French artists including Delacroix. It wins a gold medal from the French King Charles X and is sold with two other pictures to a dealer for £250.

1825 Works on *The Leaping Horse* for the R.A. exhibition; he resists persuasion to visit Paris: 'I would rather be a poor man here than a rich man abroad'.

1828 The critic of *The Times* calls him 'unquestionably the first landscape painter of the day, and yet we are told his pictures do not sell'. Maria inherits £20,000 from her father, but dies soon after; for John, 'the face of the world is totally changed'.

1829 Elected Royal Academician by one vote.

1830 Publication of mezzotints by David Lucas after Constable.

1832 Death of Archdeacon John Fisher, Constable's closest friend.

1836 Lectures on landscape at the Royal Institution.

1837 Takes the last life class held at the old studio of the R.A. in Somerset House. Dies 31 March.

PREFACE

'I shall never be a popular artist'
(Constable in a letter to his friend John Fisher in 1821)

Today, John Constable (plate 1) is the most popular of all British painters, and his *Landscape: Noon*, better known as *The Hay Wain*, is one of the most famous paintings in the world.

Constable recorded a countryside which was in his own day threatened by industry and commerce, as it still is, but which to a great extent has survived. He invested his landscapes with an intensity of affection: 'I should paint my own places best', he wrote to his friend John Fisher on 23 October 1821, 'painting is but another word for feeling'. Despite showing the darker side of the landscape – a landscape of shadows and storms, of wind and rain – he also supplied his contemporary metropolitan audience with images of a peaceful, happy, and prosperous land, inhabited and worked by busy and seemingly contented labourers.

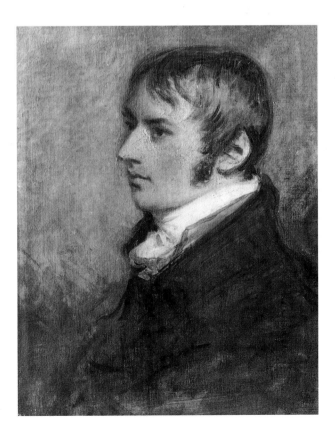

Plate 1.
Daniel Gardner
(1750–1805)
Portrait of John Constable, 1796.
Tempera,
58.5 × 45.7 cms
(23 × 18 ins).
Given by Isabel
Constable, 1888.
589–1888

His professional career, exhibiting his paintings to the public over a period of thirty-five years, was unusual and somewhat enigmatic. Constable himself felt that his work was not sufficiently appreciated, yet the critics were in fact often very appreciative, as this book will show. He was not idolised during his lifetime; his work was more admired in Paris than in London. When his studio collection was auctioned in 1838, only a small proportion was sold.

Most of the works inherited by his children were given to the Victoria and Albert Museum (the V&A) fifty years later, in 1888, by his last surviving child, his daughter Isabel. This is why the Museum possesses the largest and most comprehensive collection in the world of Constable's paintings and drawings. This book aims to introduce this magnificent collection to the public. As far as possible, I have used Constable's own words to describe his life, taken from his letters and from his conversations with his friend Charles Robert Leslie, who recorded them in his biography of the artist.

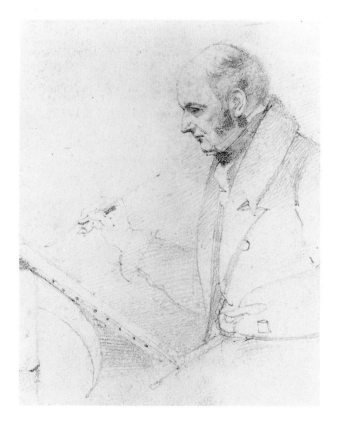

Plate 2.
Daniel Maclise (1806–70)
Portrait of John Constable,
*c.*1831. Pencil,
14.9 × 11.4 cms
(5⅞ × 4½ ins).
Maclise claimed to have
drawn this in the Life
School of the R.A. In his
biography of Constable
Leslie quotes Maclise:
'the little sketch was made
under the disadvantage of
my being on the upper and
back seat, looking down
on him as he sat on the
front and lower one'.
National Portrait Gallery

Plate 3.
Two drawings of Golding Constable's house at East Bergholt, 1814.
Inscribed 'Oct 2d.1814' and '3d Oct.' Pencil, 10.8 × 81 cms (4¼ × 3¼ ins). This is the house where Constable was born. The view is from the drive.
437–1888 [R133]

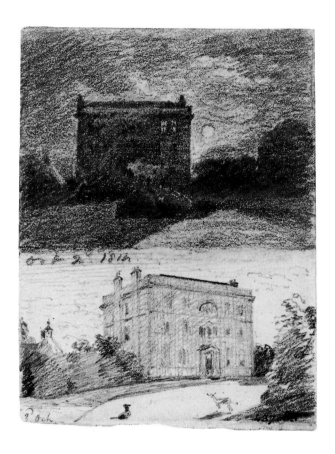

The ten chapters in this book include the history of the Constable collection at the V&A, Leslie's *Memoirs* (which act as a biography of the artist), and Constable's years as a student at the Royal Academy (R.A.). They also look at his interest in the work of the Old Masters and his methods of working, the places outside his native Suffolk to which he was devoted, the publication of the volume of mezzotints known as *English Landscape Scenery* and, finally, his lasting influence both at home and abroad.

Discussing and illustrating Constable's work from every stage in his career and in many pictorial media, the book shows the wide range and depth of Constable's achievements by including pencil and pen and ink drawing, watercolour, mezzotint printing and oil painting, and encompassing the initial sketch in a pocket notebook as well as the large finished oil paintings intended for public exhibition.

Ronald Parkinson 1998

CHAPTER 1
CONSTABLE AT THE V&A

On 31 July 1856, Sir Henry Cole, the first director of the V&A, recorded in his diary that he and the artist Richard Redgrave, the first keeper of paintings, had just visited the collector John Sheepshanks at his home near the Museum in Rutland Gate, London. Sheepshanks had indicated that 'he would make the offer of his collection to the nation', and his original idea was to open his house to the public with Redgrave as his curator. But instead, the two men suggested that his collection could be the foundation of a National Gallery of British Art at the South Kensington Museum, as the V&A was then called. A week after this visit, Cole was strolling to church from his country cottage at Shere, Surrey, when he met Redgrave, who lived nearby and who had just received a letter from Sheepshanks offering his valuable collection to the Museum. This was the first of a number of remarkable gifts and bequests, as well as a number of purchases, which has led to the great collection of paintings and drawings in oil, watercolour, chalk and pencil at the V&A today. For forty years, the collection did indeed fulfil the role of the National Gallery of British Art, until Sir Henry Tate gave his collection to the British nation and the Tate Gallery opened in London in 1897.

Among the 234 paintings in the Sheepshanks Gift were six by John Constable, including the famous *Salisbury Cathedral from the Bishop's Grounds* (front cover, plates 63 and 64). The only other Constable then in a public collection anywhere was *The Cornfield* (see plate 40), given to London's National Gallery by a body of subscribers in 1837, although Constable's *The Valley Farm*, in the 1847 Robert Vernon Gift to the National Gallery, was displayed for a brief time at the V&A. It is now housed in the Tate Gallery.

Artist and patron had met at least as early as 1829, when Sheepshanks lent Constable an engraving to copy by the Dutch landscape painter Herman van Swanevelt (c.1600–65). But although it is likely they had met some years earlier than this, only one of Sheepshanks' Constables was purchased when the artist was still alive. Four, and possibly five, of them were bought at the studio sale held by the artist's executors in 1838.

The Constable collection at the Museum continued to grow following the Sheepshanks gift. Four chalk nude studies (see plates 33 and 34), made in about 1800 when Constable was a student at the Royal Academy, were given in 1873, and in 1876 a pen and ink landscape drawing was purchased from

Plate 4.
Dedham Lock and Mill,
*c.*1816. Oil on paper,
18.1 × 24.8 cms
(7⅛ × 9¾ ins).
145–1888 [R113]

a dealer. There were also several important long loans of paintings, including two full-size oil sketches owned by the eminent collector Henry Vaughan. These were two of six 'six-footers' (as Constable called them), prepared by the artist for his series of large canal scenes painted between 1819 and 1825. On his death in 1899, it was discovered that Vaughan had bequeathed both paintings to the Museum.

But the most important acquisition, and one which to a great extent changed the character of the V&A collection of paintings as a whole, came from the artist's own family. In the 1880s the widow of Constable's son Charles lent a number of works to the Museum, but these were sold and dispersed at Christie's auction rooms in 1887 and 1890. However, his last surviving child, Isabel, had inherited and cherished the main part of the family collection. In 1888 she wrote to Richard Thompson, one of the Museum's two deputy directors and a good friend of hers, that she would like to present to South Kensington 'some landscape sketches by J. Constable RA...If this should meet with the approval of the Directors and they are accepted they can be put in a box quite ready for removal'.

This unique and magnificent gift included no less than 390 paintings and

drawings, in oil and watercolour, pen and pencil. As a result, the V&A holds the largest and most comprehensive collection of Constable's work anywhere in the world. Furthermore, after her death in 1888 Isabel left three further oil paintings to the Museum, as well as two of the greatest masterpieces in the medium of watercolour, *Old Sarum* and *Stonehenge* (plate 57). Since that year only a few more of Constable's works have been acquired, most recently a squared-up drawing for his painting *Watermeadows at Salisbury* (plate 36, already in the collection).

It is sometimes said that the V&A collection is slightly restricted as it mainly comprises the contents of the artist's studio as inherited by his family, resulting in the works showing only one aspect of Constable's genius: his intense preparation in the form of sketches and studies for the finished paintings he exhibited for sale at the R.A. annual summer shows. This is only partly true and, like the Turner Bequest now at the Tate Gallery, the V&A Constable collection gives an extraordinary and rare insight into the mind of a great artist. In the galleries and the Print Room of the V&A, it is possible to follow Constable's way of working from the merest pencil indication made in a small sketchbook, through the elaborated pen and ink, wash, or water-

Plate 5.
Dedham Lock and Mill, 1820. Oil on canvas, 53.7 × 76.2 cms (21⅛ × 30 ins). Signed and dated bottom right 'John Constable, A.R.A. pinxt. 1820'.
FA 34 (R184)

colour study, to one of the many famous oil sketches and eventually to reach the finished painting, shown in its original gilt frame as it would have been seen on the walls of the R.A. nearly 200 years ago.

The works depicting Salisbury Cathedral are a prime example of this, discussed in detail in chapter 6. Constable's creative process, his problems with composition and his triumphant command of colour are revealed both by the earliest small pencil sketch of the cathedral (plate 66, seen from across the grounds of his friend the Bishop, with whom he used to stay), and by the painting exhibited twelve years later in 1823 (front cover, plates 63 and 64).

In his own day, Constable would not have shown his preliminary sketches and studies to the public. Some connoisseurs like Sheepshanks would have enjoyed looking at them in the artist's studio, but most would have been rather shocked to see such works on a gallery wall. In 1877, the art critic John Ruskin's reaction to American painter James Whistler's 'pot of paint thrown in the public's face' was typical. But in the twentieth century the first thoughts of artists are enjoyed and appreciated: the evocative, even elusive, sketch is as interesting as the explicit statement in a highly finished canvas. The Constable collection in the V&A provides an opportunity to experience the work of one of the world's greatest artists over the whole range of his achievement, in an intimate as well as in a public context.

Constable was born in 1776, the fourth child of Golding and Ann Constable. His family had land, a good house (plates 8 and 23), a thriving business in milling and trade, and a prominent place in the local community. They lived in the village of East Bergholt, Suffolk (its population in 1801 was 970), one of a group of villages in and above the valley of the River Stour, which winds its way east to the town of Harwich and the sea. The Stour, and the villages of East Bergholt, Stratford St Mary, Langham and Dedham, are familiar to us from Constable's drawings and paintings, their mills, locks and churches appearing over and over again from different viewpoints. These scenes, in Constable's own words, 'made me a painter, and I am grateful'; 'the sound of water escaping from mill-dams etc., willows, old rotten planks, slimy posts, and brickwork, I love such things'.

When he was sixteen or seventeen, Constable joined the family business, but his ambition was already determined: to be a professional painter. Fortunately, he was encouraged from a young age by a local amateur painter, John Dunthorne, by profession a plumber and glazier. As a boy, Constable

accompanied Dunthorne on his sketching sessions in the countryside surrounding East Bergholt, and he was in effect Constable's first, if informal, art master. In 1795, Mrs Constable obtained for her son an introduction to one of the leading collectors and amateur artists in England, Sir George Howland Beaumont (1753–1827), whose mother lived in nearby Dedham. The following year he visited his uncle Thomas Allen, an amateur antiquarian who lived in Edmonton. Here he was introduced to two artists from London, probably the first professional artists he had met: the engraver John Thomas Smith (1766–1833) and the painter John Cranch (1751–1821). Smith's great work was a series of topographical views, published in 1791 as the *Antiquities of London and its Environs*, and in 1796 was planning another work, *Remarks on Rural Scenery: With twenty etchings of Cottages; from Nature; and some observations and precepts relative to the picturesque* (published in 1797). Constable was most impressed by this project, writing to Smith in October to thank him for the 'information, and advice, you so generously bestowed on me', and to inform Smith that:

I have in my walks picked up several cottages and peradventure I may have been fortunate enough to hit upon one, or two, that might please. If you think it is likely that I have, let me know and I'll send you my sketchbook and make a drawing of any you like if there should not be enough to work from.

It could be that the thirteen early drawings in pen and ink now in the V&A (plate 47), detached from a sketchbook made in 1796, were sent to Smith, but none were engraved for publication. Constable first visited London in September 1797, where he met Smith again. But it seems his mother was worried that the engraver was deflecting her son from his proper career in the family business. She wrote to Smith while Constable was still in London: 'We are anticipating the satisfaction of seeing John at home in the course of a week or 10 days, to which I look forward with hope that he will attend to business – by which means he will please his Father, and ensure his own respectability, comfort & accommodation'. Smith stayed at East Bergholt in the autumn of 1798, and it may be that his praise of his protegé's work influenced Constable's parents towards the idea of their son pursuing a career as a professional painter.

Constable seems to have found his 1796 meeting with John Cranch equally beneficial. Cranch was a painter of rustic genre scenes (his 1795 painting *Playing with Baby* is in the V&A collection), and while Smith had

encouraged Constable to draw topographical views, Cranch presumably tutored him in the use of oil paints. Two small pictures dated 1796 (now in a private collection), *The Chymist* and *The Alchymist*, could almost have been painted by Cranch himself: the subjects and the handling of pigments are very similar.

It is worth pausing here to contrast Constable's career up to 1796 with that of his almost exact contemporary, J. M. W. Turner (1775–1851). Turner was only a year older than Constable, but had been admitted as a student at the R.A. in 1789, made three sketching tours of England and Wales, seen an engraving published after one of his drawings, and exhibited his first water-colour at the R.A. in 1790 and his first oil in 1796.

Finally, in 1799, Constable's father consented to him applying to the R.A. Schools for tuition, but even then his development as a painter was slow. It may be that his own ideas on painting from nature, firmly and deeply held from a young age, conflicted too much with academic theories of landscape and other genres as they were taught in the years around 1800. On 29 May 1802, he wrote from London to John Dunthorne that he felt he had been learning about the art of landscape only from other painters' work, and that he had been: 'seeking the truth at second hand…I shall shortly return to Bergholt where I shall make some laborious studies from nature – and I shall endeavour to get a pure and unaffected representation of the scenes…with respect to colour particularly'.

His father bought him a small property in East Bergholt to use as a studio, and he moved in sometime in September 1802. A careful oil study dated that month (plate 39) depicts one of Constable's favourite views, looking from Gun Hill at Langham towards Dedham with its square-towered church, and with the Stour Estuary in the distance.

This early painting has many of the qualities associated with Constable's mature work. It was painted on a small enough board to be portable, and presumably much of the study was painted in the open air in front of the scene. It has a freshness of light, colour, and touch; at the same time it has a knowledge of compositional structure which he must have gained from looking at the works of the Old Masters, especially the French painter Claude Lorrain (1600–82) (plate 38). He characteristically uses a thin brush-line for the trunks and branches of the trees, heavier and more rapid small loaded brush-strokes for the foliage, and broader sweeps of paint in the grassy

fields and the sky. The pure white spot in the distant estuary – presumably the sail of a small boat – draws the observer into the painting, helped by the splashes of blue as short stretches of the River Stour are revealed between the trees on its banks.

Despite his fondness for places outside Suffolk – including Salisbury, where his closest friend John Fisher and his family lived; Hampstead, where he made his own family home; and other places he visited in the south-west and on the south coast – his love for the Stour valley was the deepest and most constant. He painted that same scene of Dedham church with the estuary in the distance over twenty-five years later (plate 41), although on a much larger scale, and several views around his childhood home were among his last exhibited works in the mid-1830s.

For ten years or so after he left London, Constable regularly submitted paintings for selection for display in the R.A. summer exhibitions (with the exception of the 1804 exhibition, when he seems to have been disillusioned with his peers). His working life took on a pattern: he spent the winter months in London meeting with prospective buyers and patrons, artists and other friends, attending exhibitions and R.A. events such as the annual dinner, and the summer months mostly in East Bergholt, painting both in the studio and out-of-doors. Excursions outside London and Suffolk were surprisingly few, especially for a young man over such a long period, but this lack of adventure may be linked to his simple philosophy: 'my limited and abstracted art is to be found under every hedge and in every lane'.

Exceptional trips further afield were made in 1803, 1806, and 1811. The first of these, in April 1803, was the oddest venture Constable ever undertook. He joined the East Indiaman ship *Coutts* in London to sail around to the south coast, and was on board for nearly a month, leaving the ship only to walk from Gravesend to Rochester and Chatham and back. He sailed as far as Deal, where he disembarked before the ship continued on its great voyage to China. At Chatham he made drawings of the British fleet, including the famous *HMS Victory*. His biographer Leslie records that Constable made about 130 drawings on this trip; he seems to have been attracted to the rigging of the ships in the same way that he was fascinated by the workings of farm, lock, and mill equipment. He also experienced rapid changes in climate, always a major preoccupation of the artist, and wrote to John Dunthorne after his return: 'I saw all sorts of weather. Some the most

Plate 6. (*opposite, top*) *Matlock High Tor*, 1801. Pencil and sepia wash, 17.5 × 26.4 cms (6⅞ × 10⅜ ins). Inscribed (almost illegibly) by the artist top right 'Matlock Tor...4 1801'. 247a–1888 [R21]

Plate 7. (*opposite, bottom*) *View in Borrowdale*, 1806. Pencil and watercolour, 19.1 × 27.4 cms (7½ × 10¾ ins). Inscribed by the artist on the back 'Borrowdale 4 Oct 1806 – Dark Autumnal day at noon – tone more blooming than this...the effect exceeding terrific – and much like the beautiful Gaspard [Poussin] I saw in Margaret St'. 187–1888 [R80]

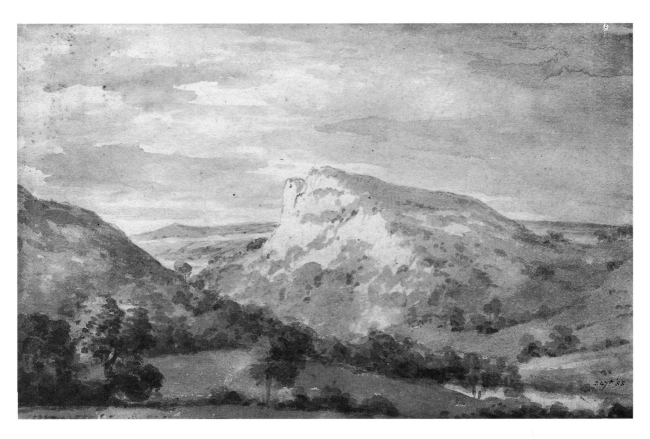

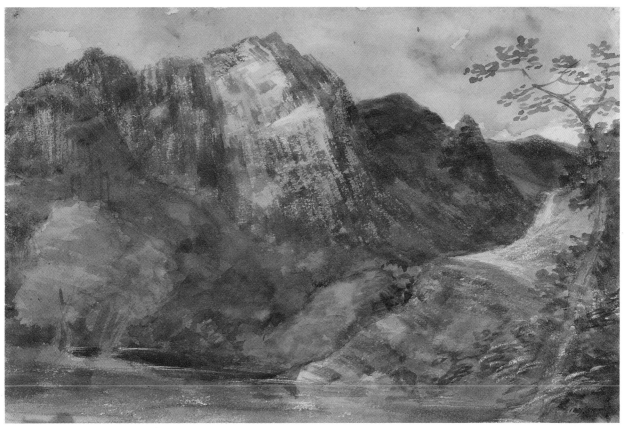

delightful, and some as melancholy. But such is the enviable state of a painter that he finds delight in every dress nature can possibly assume'. This is a statement Turner might well have made.

A more conventional excursion was undertaken in the autumn of 1806, a two-month (and his only) tour of the Lake District. Constable's uncle, his mother's eldest brother, was the wealthy philanthropist David Pike Watts (1754–1816). He suggested and financed the young artist's visit to the Lakes, where he owned Storrs Hall on Lake Windermere. Constable was accompanied by his friend George Gardner, whose father, Daniel Gardner, had painted Constable's portrait ten years before (plate 1). The Lakes had long been an equivalent of the classical Arcadia for British artists, and for Constable the tour was a good substitute for the Grand Tour of Europe – not that he was ever interested in travelling abroad – which was rendered impossible during the Napoleonic wars. Their neighbours at Storrs, John and Jessy Harden, recorded Constable's two visits to them in letters and drawings (published in the magazine *Country Life*, 16 April 1938). They recounted how Constable secured portrait commissions from their friends the Lloyds, and Jessy considered him 'a genteel handsome youth'. She also wrote to her

Plate 8.
View at East Bergholt over the Kitchen Garden at Golding Constable's House, 1814.
Pencil, 30.2 × 44.9 cms (11⅞ × 17¾ ins).
Probably exhibited at the R.A. 1815.
623–1888 [R176]

Plate 9.
Dedham Vale: Evening,
1802. Oil on canvas,
31.8 × 43.2 cms
(12½ × 17 ins).
587–1888 [R36]

Plate 10.
Study of clouds, 1822.
Oil on paper,
29.8 × 48.3 cms
(11¾ × 19 ins).
Inscribed by the artist on
the back 'Sepr.5.1822.
looking S.E.noon.
Wind very brisk. & effect
bright and fresh. Clouds.
moving very fast. with
occasional very bright
openings to the blue'.
590–1888 [R249]

sister: 'Yesterday rained all day, so Mr Constable got some oil colours and painted a portrait of me which he executed wonderfully considering he was only five hours about it. He is a clever young man but I think paints rather too much for effect'.

Constable's reaction to the spectacular scenery of the Lake District was most famously recorded by Leslie: 'I have heard him say the solitude of mountains oppressed his spirits'; it is possible that the sheer scale, ruggedness and volatility of the Westmorland landscape, so very different from that of Suffolk, daunted him. His studies ranged from the typically 'Picturesque' (an adaptation of an actual landscape to look like a picture by such Old Masters as Claude and Poussin) to the stormy essay in the 'Sublime' (a concept of landscape that was awe-inspiring, terrible and stupendous, plate 6). He seems to have developed some of his drawings and watercolours into oil paintings for exhibition at the R.A. in 1807 and 1808, although their present whereabouts are now unknown. But perhaps the key word in Leslie's report is 'solitude'. Leslie went on to write: 'His nature was peculiarly social and could not feel satisfied with scenery, however grand in itself, that did not abound in human associations. He required villages, churches, farmhouses and

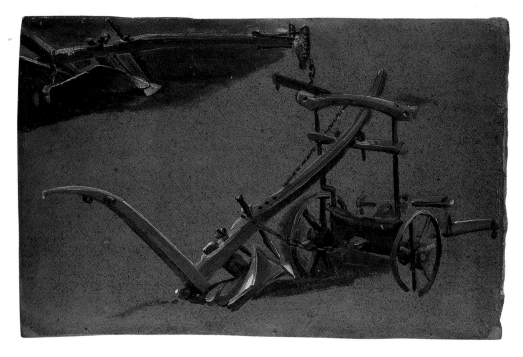

Plate 11.
Studies of two ploughs, 1814. Oil on paper, 17.2 × 26 cms (6¾ × 10¼ ins). Inscribed, probably by the artist, '2d Novr.1814'. 789–1888 [R136]

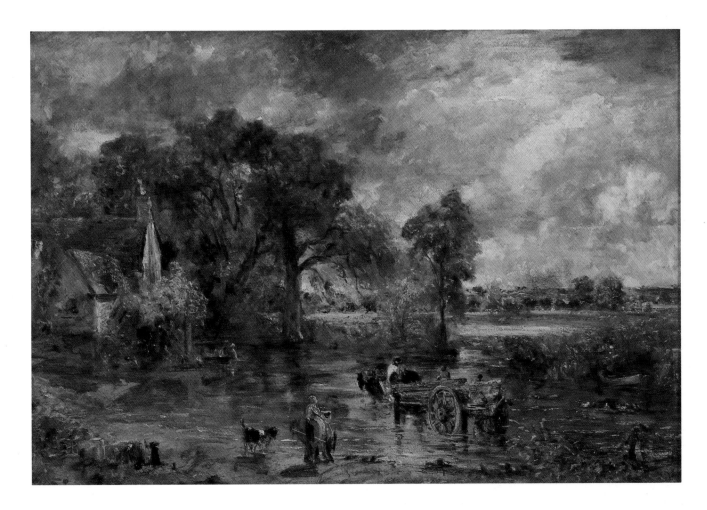

Plate 16. (*opposite*)
*Willy Lott's house, near
Flatford Mill, c.1811.*
Oil on paper,
24.1 × 18.1 cms
(9½ × 7⅛ ins).
166–1888 [R110]

Plate 17.
*Full-scale study for
'The Hay-Wain', c.1821.*
Oil on canvas,
137 × 188 cms
(54 × 74 ins).
987–1900 [R209]

broader spectrum of emotions. That this was important to him is demonstrated by his statement that 'painting is with me another word for feeling', and in his mature works we find serenity or verve in sparkling views in bright morning sunshine, and dark, stormy images drenched in rain and battered by wind. It is interesting that one biography of Constable, by Andrew Shirley, is titled *The Rainbow*, a natural phenomenon created by both sun and rain. The rainbow was one of Constable's favourite subjects, either as part of a composition or in its own right (plate 57).

Constable's recognition by the R.A. and contemporary critics was slow to emerge. Elected an Associate of the Academy in 1819 and a full Member ten years later, his patrons remained few in number. Despite his complaints about the treatment he felt he had received from the public, he made a good living, and achieved fame in the 1820s both in Britain and in France. But when success came, continuing personal happiness was denied him.

CHAPTER 2
C. R. LESLIE AND HIS MEMOIRS
OF CONSTABLE

Much of what is known about Constable's life and career comes from his letters, most of which were collected and edited by R. B. Beckett and published in the 1960s by the Suffolk Record Office. One of Constable's earliest acquaintances in London was Joseph Farington, whose detailed diary between 1793 and 1814 is a particularly valuable source of information for Constable's early years. In recent years it has been published in full. Most important, however, is the biography written by his friend, the artist Charles Robert Leslie (plates 18 and 19).

Leslie was born in London in 1794 of American parents, and as a young child went with them to Philadelphia in 1799. He returned to England in 1811 at the age of seventeen to study in the R.A. Schools. He had met Constable by about 1817, and noted down their talks, kept his letters, and had access to correspondence between Constable and others, notably the

Plate 18.
David Lucas (1802–81),
after C. R. Leslie,
*Portrait of John
Constable*, c.1830.
Mezzotint,
published 1843,
14.5 × 13.3 cms
(6⅝ × 5⅛ ins).
The original painting is
in the R.A. collection.
28298.2

Plate 19.
Charles Robert Leslie
R.A. (1794–1859),
Self-portrait.
Engraving, 10.3 × 8 cms
(4⅛ × 3⅛ ins).
This was engraved
for the frontispiece
of the painter's
*Autobiographical
Recollections,*
first published in 1860.
National Art Library

artist's closest friend, the younger John Fisher. These provided the basis for his *Memoirs of the Life of John Constable, Composed Chiefly from his Letters,* first published in 1843, six years after Constable's death, and revised and expanded for a second edition two years later. The biography is not only a remarkable account of a great artist by someone who had known him well for roughly twenty years, but is also a text which is largely in Constable's own words, quoted from letters or remembered conversations.

At this time there was hardly any tradition in England of compiling the lives of artists, apart from obituaries in magazines and newspapers, and entries in biographical dictionaries. Only the four painter-Presidents of the R.A. in office during Constable's lifetime achieved some degree of immortality through their biographers: *The Memoirs of Joshua Reynolds,* by his pupil James Northcote, was published 1813–15, *The Life and Works of Benjamin West* by the professional novelist and essayist John Galt dates from 1816–20, *The Life and Correspondence of Thomas Lawrence* by D. E. Williams appeared in 1831, and *The Life of Martin Archer Shee,* written by his son, was published in 1860. It seems clear that it was Galt's biography of West, 'composed from materials furnished by [West] himself', that gave Leslie the idea and the form of his memoirs of Constable. Like Leslie, West was American, and was the President of the R.A. during Leslie's studentship.

Plate 20. *East Bergholt Street, East Bergholt*, c.1796–9. Pen and watercolour, 19.5 × 32.1 cms (7⅝ × 12⅝ ins). In 1802, Constable purchased two properties in this street: a house and a cottage. The artist did not make a will, so on his death they automatically passed to his son, Lionel Bicknell Constable. 625–1888 [R14]

Plate 21. *The valley of the Stour, looking towards East Bergholt*, 1800. Pen and watercolour, 33.8 × 52.3 cms (13⅜ × 20⅝ ins). One of a set of four drawings, three of which are in the V&A, made by Constable as a wedding gift for one of his childhood friends, Lucy Hurlock. Together, they make up a considerably detailed panoramic view of the Stour valley. P.27–1970 [R16c]

Plate 22.
The valley of the Stour, with Dedham in the distance, c.1805. Oil on paper laid on canvas, 48.8 × 59.8 cms (19⅛ × 23½ ins). Constable had painted this view before, in a vertical format. The use of paper suggests this was painted out-of-doors: despite its attachment to a canvas, the pin-holes which would have fastened the paper to his drawing board are still visible. 321–1888 [R63]

Leslie's memoir begins with the artist's own words, taken from Constable's book of mezzotints, *English Landscape Scenery* (first published in 1830; see chapter 9). He is describing his birthplace in Suffolk, the village of East Bergholt:

It is pleasantly situated in the most cultivated part of Suffolk, on a spot which overlooks the fertile valley of the Stour, which river separates that county on the south from Essex. The beauty of the surrounding scenery, its gentle declivities, its luxuriant meadow flats sprinkled with flocks and herds, its well cultivated uplands, its woods and rivers, with numerous scattered villages and churches, farms and picturesque cottages, all impart to this particular spot an amenity and elegance hardly anywhere else to be found.

It was this countryside, the 'scenes of his boyhood', which Constable said made him a painter (plates 20, 21 and 22), and it was here that, as a boy, he accompanied local amateur painter John Dunthorne on sketching excursions.

31

He also went on a sketching tour of Norfolk with one of his father's clerks, a Mr Parmeter, around the same time.

Golding Constable, Constable's father, was the son of a farmer, and had inherited Flatford Mill in Suffolk from his uncle together with a good deal of money and land. He developed a very profitable business, moving from milling grain to trading in corn and coal, and administering the canalization of the rivers for transport. He bought land, became well-respected in the local community, and built a fine mansion at East Bergholt (plate 23). John was born at the house, the fourth of six children, on 11 June 1776.

After attending various local schools, he joined the family business around the age of sixteen. It was two years later that Constable was introduced to the collector and amateur painter Sir George Beaumont, and the following summer, in 1796, when he began to make other contacts in the London art world, such as the two artists, John Thomas Smith and John Cranch. For the next two years, Constable seems to have campaigned – with Smith's help – to study art at the R.A. in London. Early in 1799 his father relented, and John enrolled as a probationary student. Three years later, he exhibited his first painting, and went for interview at Windsor for a post as military drawing master. Both Joseph Farington and the R.A. President himself, Benjamin West, advised him against taking the job, saying 'he stood in no need of it', and Constable confessed to his friend John Dunthorne in a letter of 29 May 1802 that 'it would have been a death blow to all my prospects of perfection in the Art I love'.

Plate 23.
Mr Golding Constable's house, East Bergholt, the Birthplace of the Painter,
c.1809–10.
Oil on millboard laid on panel, 18.1 × 50.5 cms
(7⅛ × 19⅞ ins).
The panoramic view is from the fields behind the house. The village church is on the left and the stable block on the right. Constable's mother Ann died in 1815, his father Golding in 1816, and in 1819 the house and its contents were sold.
The house was demolished in 1840–1.
583–1888 [R102]

It is worth remembering here that Constable's financial circumstances, unlike those of Turner and most young professional artists, were very comfortable. Although he constantly complained in his letters that he needed money, Constable never really felt the pressure to make a living by working for engravers or picture dealers, instead enjoying the luxury of being able to determine for himself the development of his chosen career. Consequently, after the 1802 R.A. summer exhibition opened, he was able to write to Dunthorne a now famous letter, which Leslie quotes at length:

For these few weeks past I believe I have thought more seriously on my profession than at any other time of my life...And this morning I am the more inclined to mention the subject having just returned from a visit to Sir G. Beaumont's pictures. – I am returned with a deep conviction of the truth of Sir Joshua Reynolds's observation that 'there is no easy way of becoming a good painter'. It can only be obtained by long contemplation and incessant labour in the executive part...For these past two years I have been running after pictures and seeking the truth at second hand...I shall shortly return to Bergholt where I shall make some laborious studies from nature – and I shall endeavour to get a pure and unaffected representation of the scenes that may employ me with respect to colour particularly...There is little or nothing in the exhibition worth looking up to – there is room enough for a natural painter.

The rest of Constable's life and career may be seen as the fulfillment of the aims expressed in this letter, and the words 'there is room enough for a natural painter' prophesy his eventual place in the history of art as a 'natural painter'. The various aspects of his work at the R.A., at Salisbury, Brighton and Hampstead are explored later this book.

What we know of Constable's private life is dominated by his happy marriage to Maria Bicknell, the daughter of an eminent solicitor. Her father opposed their marriage, which eventually took place in 1816. They had seven children and Maria, never very strong, suffered gradually deteriorating health. Despite 'cures' on the coast at Brighton, she fell seriously ill after the birth of their last child in January 1828, and died in November. Constable wrote to his brother Golding: 'hourly do I feel the loss of my departed Angel – God only knows how my children will be brought up...the face of the World is totally changed to me'. During the 1830s, until his death in 1837 at the age of sixty, Constable experienced the loss of other friends, among them his early mentor John Dunthorne; the latter's son, also John, who was Constable's studio assistant; the younger John Fisher; and Sir George

Beaumont. These deaths triggered what he called his 'black moods'; Leslie described him as 'a prey to melancholy and anxious thoughts'.

It has been suggested that certain of the aggressively rendered later paintings and sepia drawings visually express this inner emotional turmoil (plate 24). This may well be so but, on the other hand, the later works never lack control, and the apparently spontaneous effects in such works as Hadleigh Castle (plate 99) are actually worked out with great care. It is this desire to see the man in his work, the work as an expression of the man, which remains a legacy of the Romantic Movement. Moreover, there are works from the last five years of Constable's life which are sunny and serene (plate 25), expressing as much joy in nature, especially in his beloved Dedham Vale, as in paintings from over thirty years before. As late as 1834, Constable seems to have been planning another 'six-footer': a canal scene, presumably set on the River Stour, for which one of the oil sketches is in the V&A (plate 26). It is bright and sparkling in colour and the handling of paint

Plate 25. (*opposite top*) *Englefield House, Berkshire*, 1832. Pencil, pen and ink, and watercolour, 11.5 × 19.2 cms (4½ × 7½ ins). Inscribed by the artist bottom left 'Inglefield House Rd.Benyon de Bouvir Esq.Berkshire. left London for the above place Augt 22.1832.with Lane'. 345–1888 [R340]

Plate 26. (*opposite bottom*) *A river scene, with a farmhouse near the water's edge, c.*1834. Oil on canvas, 25.4 × 34.9 cms (10 × 13¾ ins). 141–1888 [R403]

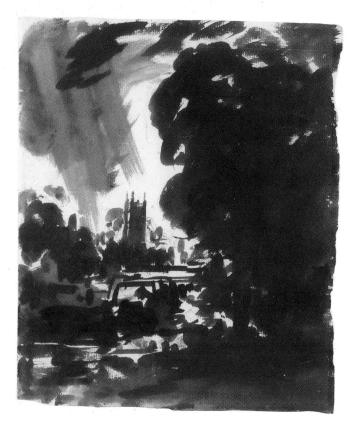

Plate 24.
*View on the Stour: Dedham Church in the distance, c.*1836. Pencil and sepia wash, 20.5 × 16.9 cms (8 × 6⅝ ins). 249–1888 [R410]

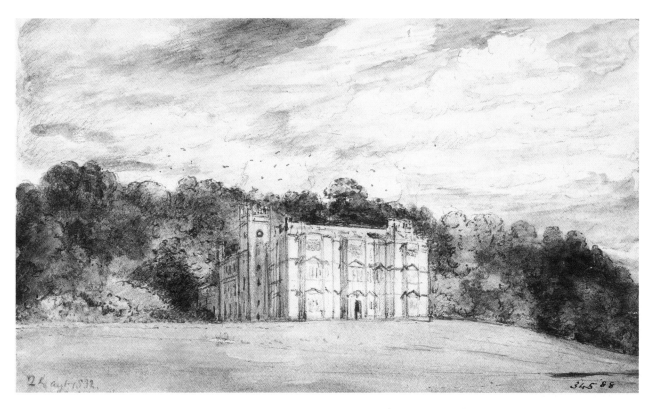

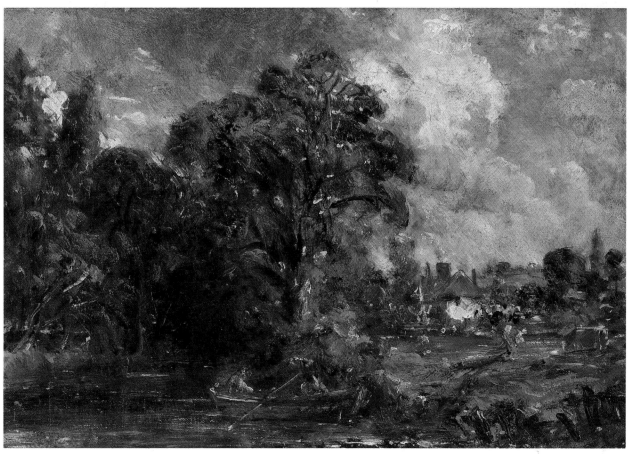

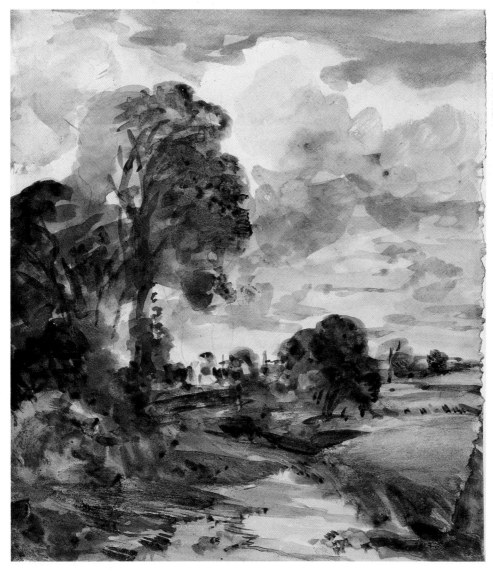

Plate 27. *Landscape Study (A Country Lane)*, *c*.1836. Pencil and watercolour,
21.3 × 18.3 cms (8⅜ × 7¼ ins). 203–1888 [R415]

is equally brilliant, especially in the touches of white and red. What seems to
be one of his last watercolours (plate 27), and possibly his last orchestration
of Claude's *Hagar* composition (see chapter 4 and plate 38), is also clear and
bright in colour, rapid and vivacious in handling.

Leslie's first recorded memory of Constable was in London in 1817, 'living
in a small house, No.1, Keppel Street, Russell Square'; 'his first child...might
be seen almost as often in his arms as in those of his nurse, or even his
mother. His fondness for children exceeded, indeed, that of any man I ever
knew'. It seems that they became friends when they both stood for election to
Associateship of the R.A. in 1819; in the event, Constable won with eight
votes against Leslie's five. In 1826 they were rivals again, this time for

election to full membership: Leslie was elected, which must have been especially galling for Constable as he had been awarded a gold medal at the Paris Salon the previous year. But in fact their friendship flourished and deepened. In his own *Autobiographical Recollections*, published in 1860, Leslie wrote that 'I had been for some time what is called acquainted with Constable, but it was only by degrees and in the course of years that I became really acquainted either with his worth as a man, or his true value as an artist'. The Constables moved into a house at 35 Charlotte Street, in London, in 1822, and a year or so later Leslie took an apartment a few doors away. In 1837, twenty years after their first recorded meeting, Leslie was walking with Constable along Oxford Street when: 'he crossed over to a little beggar girl who had hurt her knee; he gave her a shilling and some kind words...we parted at the west end of Oxford Street, laughing. – I never saw him again alive'. Again in his *Autobiographical Recollections*, Leslie explained his friendship with Constable thus:

Of all the painters I have known – and I have been intimate with all the most eminent of my time – Constable was to me the most interesting, both as a man and an artist. I have been told that my great admiration of his pictures arose out of my personal acquaintance with him; but the reverse was really the case; my acquaintance with him arose out of my admiration of his pictures. I cultivated his friendship because I liked his art...he put his soul into his art...nobody knew better than Constable that without imagination there could be no true art... He had not a very large circle of friends; but his friends, like the admirers of his pictures, compensated for their fewness by their sincerity and their warmth.

Later, in only one sentence, Leslie sums up much of how Constable's work is still thought of today: 'He followed, and for his future fame he was right in following, his own feelings in the choice of subject and the mode of treatment'.

Perhaps one of the most vivid evocations of 'Constable, the man' is also found in *Autobiographical Recollections*. Not long after the artist's death, Leslie took a hackney coach from Constable's house. At the end of his journey the driver said to him: 'I knew Mr Constable; and when I heard he was dead, I was as sorry as if he had been my own father – he was as nice a man as that, Sir'.

CHAPTER 3

CONSTABLE AND THE ROYAL ACADEMY

From its foundation in 1768 until the early twentieth century, the Royal Academy was the centre of the British art world. It was founded as an institution for both training young artists in its Schools and displaying contemporary art in regular annual summer exhibitions; functions which the R.A. still undertakes today. But the R.A. was also important as a focus for the profession and its very existence was, and still is, an official and public affirmation of the status of the pictorial arts in the lives and hearts of the British nation.

Constable's relationship with the Academy was unconventional, partly because landscape painting was rated even lower in the hierarchy of subject matter than 'the exhibition of animal life', according to the Academy's founder and first President, Sir Joshua Reynolds. At the apex of this academic hierarchy was History painting – classical, mythological or Biblical – in the 'Grand Manner' of the Old Masters. But, at the same time, Constable's relationship with the R.A. was very close; he studied in the R.A. Schools, stood for election first as Associate and then as full Royal Academician, regularly showed his paintings at the annual summer exhibitions, sat on committees, conducted classes and gave public lectures.

The Royal Academy of Arts was officially founded on 10 December 1768. Until this point, the nearest that Britain had got to rivalling the great and long-established academies of Florence and Rome – and especially the Académie Royale in Paris – was the establishment in the Middle Ages of the Painter-Stainers Company (a guild checking the quality of apprentices' craftsmanship), followed by various later 'academies' such as the School for Painting and Drawing from Life (founded in 1711), the St Martin's Lane Academy (run by the decorative painter Sir James Thornhill and later his son-in-law the painter and engraver William Hogarth) and two exhibition societies flourishing in the early 1760s, the Society of Artists and the Free Society of Artists.

According to the letter of proposal submitted to George III on 28 November 1768, signed by 22 'Painters, Sculptors, and Architects of this metropolis', the aim was to establish:

a Society for promoting the Arts of Design...the two principal objects we have in view are, the establishing of a well-regulated School or Academy of Design, for the use of students in the Arts, and an Annual Exhibition, open to all artists of distinguished merit, where they may offer their performances to public

Plate 28. *(opposite, top)* P. A. Martini after H. Ramberg, *The Exhibition of the Royal Academy, 1787.* 1787. Engraving, 36 × 49.8 cms (14⅛ × 19⅝ ins). Although very artificially composed, this scene provides a vivid record of how paintings were hung – floor to ceiling, frame to frame – and of the private view as a social occasion, with ladies and gentlemen talking, flirting and even looking at the paintings. Were dogs really allowed into the exhibition rooms? The top natural light through the large arched windows and the deep red fabric hangings would have complemented the paintings and their gilt frames. 27807

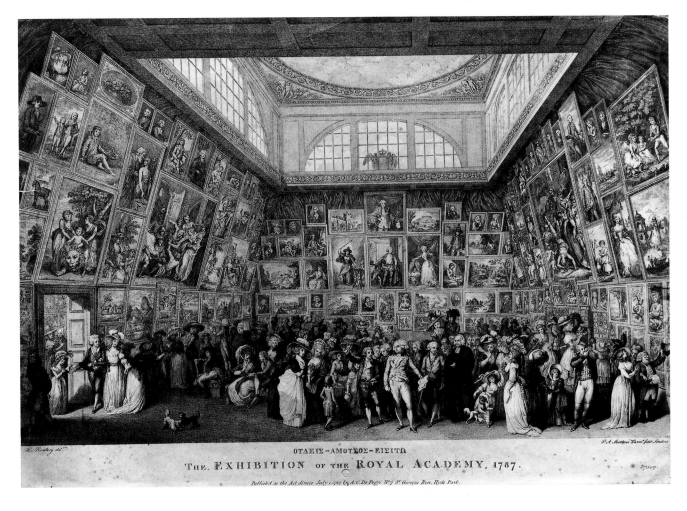

OTΔΕΙΣ-ΑΜΟΤΣΟΣ-ΕΙΣΙΤΩ

THE EXHIBITION OF THE ROYAL ACADEMY, 1787.

Publish'd as the Act directs July 1 1787 by A.C De Poggi N°7 St Georges Row, Hyde Park.

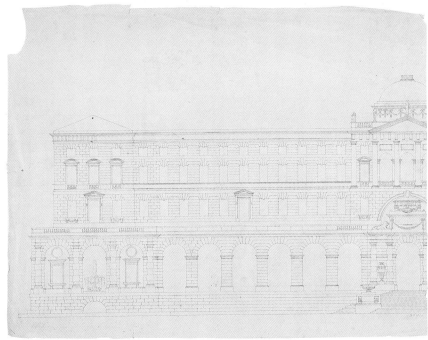

Plate 29.
Sir William Chambers R.A.,
*Somerset House: Partial Elevation
of the River-block Front, c.*1777.
Pencil, pen and ink, 37.3 × 47.2 cms
(14½ × 18½ ins). This is an early
design for what was to be the largest
architectural project in Britain of the
18th century, at a final cost of the
huge sum of nearly half a million
pounds. Principally it was to house
government offices, but also the
Royal Society, the Society of
Antiquaries, and the studios and
exhibition rooms of the R.A.
3391

inspection, and acquire that degree of reputation and encouragement which they shall be deemed to deserve.

These twin aims were realised, and continue today; the principal innovation has been the staging since 1870 of important loan exhibitions, first only in the winter months and now all through the year. The first premises were situated on the south side of London's Pall Mall, with the Schools moving into the palace of Old Somerset House in 1771, followed by the summer exhibitions from 1779 (plate 28). When the old palace was demolished, the new Somerset House designed by Sir William Chambers (a founder member of the R.A.) incorporated a special block for the Academy (plate 29) where it remained until 1837 when it moved to a wing of the new National Gallery in Trafalgar Square. It eventually moved to its present home in Burlington House, Piccadilly, in its centenary year of 1868.

The staff structure and the teaching timetables were determined from the start. Under the President, there was to be a Keeper, nine 'Visitors' to teach and examine the students in the Schools in rotation, and Professors of Perspective and Geometry, Anatomy, Architecture, and Painting, each giving six public lectures a year. All except the Professor of Anatomy were elected in a ballot from among the Academicians. Seventy-seven students were admitted in the first year, with an average of twenty-five each year thereafter. Remarkably, all the tuition was (and remains to this day) free of any charge to the student, who only had to provide his or her own art materials.

To gain admission to the R.A. Schools, the student had to submit a drawing of an antique sculpture (most likely made in the galleries of the British Museum). Since the Renaissance, the basis of training for all young artists had been the study of anatomy, from classical Greek and Roman sculpture and from living models. The next stage was to present a drawing after one of the casts of classical sculpture in the R.A.'s own study collection (plate 30). If successful, the student would enter the Antique, or Plaister (plaster) Academy, which was open every day except Sunday from 9 am–3 pm, with some evening sessions. A different cast or casts would be offered each week for the students to draw. The R.A. register – a signing-in book – records, for example, that Turner attended 130 sessions over a period of four years. Unfortunately the registers for the years Constable was a student have not survived. The register for the R.A. Library does still exist, however, but Constable's name does not appear; over the years signatures in

Plate 30. *(opposite)* C. Bestland after Henry Singleton, *The Royal Academicians assembled in their Council Chamber*, published 1802. Engraving, 64.5 × 80 cms (25⅞ × 31½ ins). This artificially composed scene shows an assembly to determine which students should be awarded medals for their work. Plaster casts of some of the most celebrated classical sculptures can be seen: from left to right, the bust of one of the 'Farnese Captives', the 'Belvedere Torso' (of which both Constable and Turner made studies), the 'Discobolus', the 'Laocoön', the 'Medici Venus' and the 'Apollo Belvedere'. Benjamin West is seated in the President's chair to the left, while Joseph Farington stands full-length in profile equally prominently on the right. The original painting is in the R.A.
22014

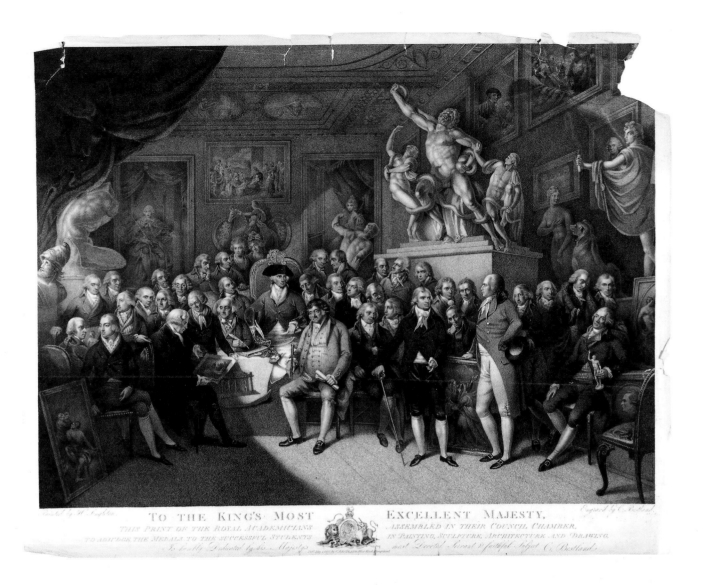

the Library registers have been cut out by collectors, perhaps including some of Constable's.

Once a student had finished at the Antique Academy, he graduated to the Academy of Living Models – what is now called the Life Class. To draw from the female model, the student had to be at least twenty years old, or married. Six evenings a week, two models alternated for two-hour classes, from 4 pm in summer and 6 pm in winter. The models would often adopt poses taken from an Old Master painting or classical sculpture. There were two terms, from September to April and May to August, with short vacations for Christmas and other public holidays. Classes were conducted by the Visitors. The combined period of study recommended for the two Academies was six years, increased to seven in 1892, although the rules of attendance seem to have been flexible. The extensive Library was especially useful for the study of books of engravings after Old Master paintings and classical sculptures.

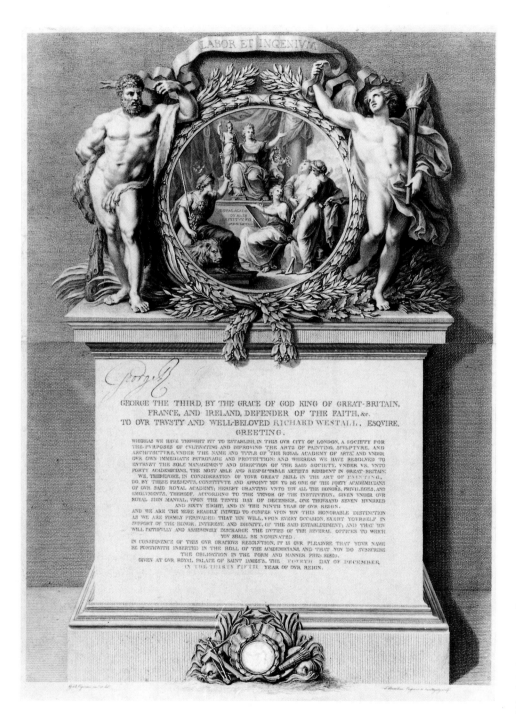

Plate 31.
F. Bartolozzi after
G. B. Cipriani,
*The R.A. Diploma
presented to the painter
Richard Westall*, 1795.
Engraving, 65 × 45.8 cms
(25½ × 18 ins). The diploma
is in two parts: the upper
section bears an image of
the seven liberal arts,
flanked by the figures of
Hercules and Apollo.
27745.1,2

The ultimate aim of the student was to be elected an Associate of the Royal Academy, and eventually a full Royal Academician. This allowed artists to use the initials A.R.A., and then R.A., after their names. On election, the artist was expected to deposit a 'diploma picture' with the R.A: Constable's was, unsurprisingly, *A Boat passing a Lock*, a scene on the River Stour at Flatford, one of the much-loved views that inspired him to become an artist. He had painted it in 1826 for a James Carpenter, and exchanged it for another picture when he was elected R.A. in 1829. The diploma itself had been designed by Giovanni Baptista Cipriani (1727–85), himself a founder member of the R.A. (plate 31).

Constable came to London in 1799 at the age of twenty-two, having finally obtained permission from his father to study painting. At the end of January he had visited his friends the Cobbolds at Ipswich; Mrs Elizabeth Cobbold

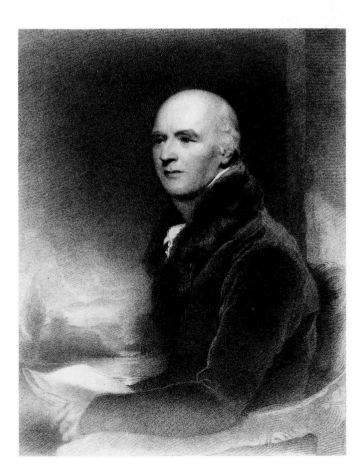

Plate 32. H. Meyer after Sir Thomas Lawrence P.R.A., *Portrait of Joseph Farington RA*, published 1814. Mezzotint, 32.9 × 25 cms (13 × 9⅞ ins). The original oil painting of 1808 is now in the Museo Nacional de Bellas Artes, Buenos Aires. Farington was a close friend and adviser of Lawrence's from the early 1790s. 27213

was a poet and amateur artist, and she gave him a letter of introduction to the Royal Academician Joseph Farington (1747–1821), which Constable presented to him in London on February 25. This was very fortunate for Constable. Having been a pupil of Richard Wilson, Farington (plate 32) was a vital link with the great tradition of British landscape painting. He had learned from Wilson that the true beauty of landscape painting derived not only from the study of the works of such Old Masters as Claude (1600–82) and Nicolas Poussin (1593/4–1665), but also in the observation and depiction of actual places. These places might be transformed by the artist into a 'Picturesque' composition, but the basis of the painting was the real experience of the scene, an experience the young Constable already knew. Farington wrote a 'Biographical Note' on Richard Wilson, explaining that 'his admiration of the pictures of Claude could not be exceeded, but he contemplated those excellent works and compared them with what he saw in nature to refine his feeling and make his observations more exact'.

Even more important for Constable was Farington's exalted position in the London art world. Born into the landed gentry Farington had, unusually for his social background, entered at the age of sixteen the studio of Richard Wilson (in the Great Piazza, Covent Garden). The following year, in 1764, the Society of Artists awarded him a prize for a landscape drawing, and he was elected a Member of the Society a year later, becoming one of its Directors in 1772. Meanwhile, Wilson had become one of the founder-members of the R.A.; Farington, one of the R.A.'s first students, was formally admitted in March 1769. He was elected Associate of the R.A. in 1783, and full Royal Academician in 1785. He worked principally, and highly successfully, as a topographical draughtsman, but he was most famous in his own day as a central figure in the R.A. and its circle. Today Farington is even more famous for his diary, which he began in 1793 and continued until his death, recording almost everyone he met and everything he did, much like Samuel Pepys. It has provided a valuable record of the minutiae of the art world of his time.

Although Farington never held any official position in the R.A., his influence in the art world was considerable, for several reasons. Not only was he from a higher social class than most artists, but he had a natural talent for administration, he was acquainted with several of the most eminent men of the day (the politician Sir Robert Walpole, the influential poet and critic

Dr Samuel Johnson and historian Edward Gibbon, for example), and he was an artistic link with the great Richard Wilson. His ascendancy to power, however, did not please all his contemporaries. William Beechey called him 'Warwick the Kingmaker' (see Farington's diary entry for 24 April 1796), and William Sandby, in his *History of the Royal Academy* (1862), noted: 'he possessed a degree of weight in the counsels of the Academy far beyond any other member – so much so that with some he bore the appellation of "Dictator of the Royal Academy"'.

Another contemporary, the painter James Northcote (in *Conversations of James Northcote with James Ward*, not published until 1901) remarked 'How Farington loved to rule the Academy! He was the great man, to be looked up to on all occasions; all applicants must gain their point through him', and thought that 'he cared nothing at all about pictures; his great passion was the love of power – he loved to rule'.

Constable showed Farington some of his Dedham sketches, and prepared a study from a cast which almost immediately, on 4 March, secured his admission as a Probationer at the R.A. The cast was of the Belvedere torso (see plate 30), one of the most famous classical Roman sculptures in the Western world, and had been presented to the R.A. by the sculptor Joseph Nollekens (1737–1823). Constable was fully registered in the R.A. Schools on 21 June 1800, at the age of twenty-four; Turner, on the other hand, had been accepted in 1789 at the age of fifteen. (The average age of entrants in 1800 was about twenty, the youngest being the fourteen-year-old William Mulready, and the oldest twenty-seven.) Of Constable's most immediate contemporaries, only Mulready and Thomas Uwins are now well-known. Henry Salt and Richard Mears, for example, also entered the Schools in 1800, but never exhibited a work at the summer exhibition and are now little more than names in the R.A. records. It would be interesting to know more of Louis de la Monpeye, a student also admitted at the same time as Constable who gave his profession as 'Amusement'. The President was then the American-born historical painter Benjamin West, the Keeper was the eminent sculptor Joseph Wilton, the Professor of Painting the eccentric Swiss-born Henry Fuseli, and the Professor of Architecture the avant-garde classicist George Dance.

As was usual, Constable's first training was in drawing from plaster casts, before graduating to the Life Schools. The life study illustrated here (plate

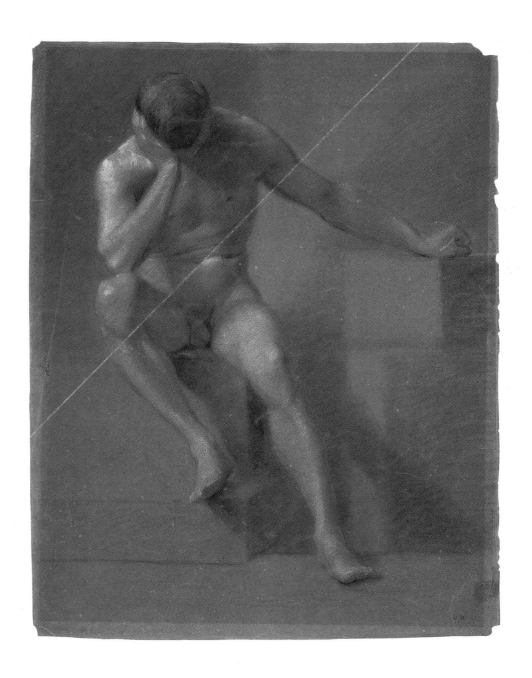

Plate 33. *Study of a seated male nude*, *c*.1800. Black and white chalk on brown paper,
55.5 × 43.8 cms (21¾ × 17¼ ins). Inscribed 'Drawn by my Father John Constable R.A.
C.G. Constable' on the back. Leslie wrote: 'I have seen no studies made by Constable at
the [R.A.] from the antique, but many chalk drawings and oil paintings from the living
model, all of which have great breadth of light and shade, though they are sometimes
defective in outline'. 42–1873 [R17]

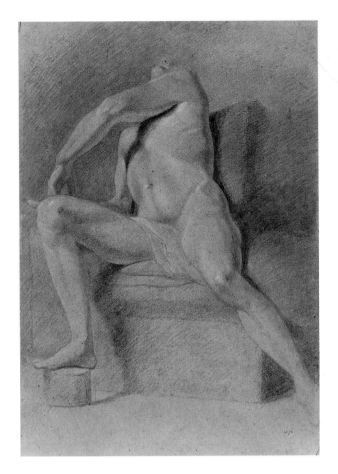
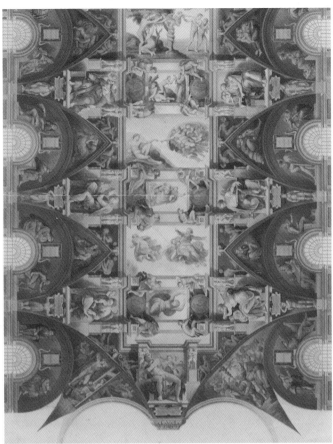

Plate 34. (*left*) *Study of a nude male figure, c.*1800. Charcoal, and black and white chalks on grey paper, 51.8 × 36 cms (20⅜ × 14⅛ ins). The model was clearly required to adopt the pose of one of the famous 'ignudi' (male nudes) from Michelangelo's ceiling fresco for the Sistine Chapel (see plate 35). 45–1873 (E.3005–1911) [R20]

Plate 35. (*right*) Anon, British, early 19th century, *The Sistine Chapel ceiling, the Vatican, Rome* (detail). Lithograph, 47 × 101.3 cms (18⅝ × 39⅞ ins). This print is lettered: *To Charles Lock Eastlake, President of the Royal Academy etc, etc, etc, whose works and whose influence have ever tended to foster a taste for the highest style of Art – this Lithographic Print of the Ceiling of the Sistine Chapel by Michael Angelo executed at the expense of J. R. Harford Esq of Blaise Castle is inscribed by him with every sentiment of respect and esteem.* E.946–1886

33), for example, has some features in common with the Belvedere torso (plate 30). Another early life drawing by Constable (plate 34) shows the model posed in the attitude of a figure from Michelangelo's fresco on the Sistine Chapel ceiling (plate 35).

In 1802 Constable exhibited his first painting in the summer exhibition; the title in the catalogue was simply *A Landscape*, which makes its identification today rather difficult, but it was probably *The Edge of a Wood*, now in the Art Gallery of Toronto, Canada. He exhibited at the R.A. every summer until his death, with the exception of 1804 when he told Farington in a fit of pique

JOHN CONSTABLE

that he did not want to show his paintings in competition 'with works which are extravagant in colour and bad taste wanting truth'. In 1814 he first stood for election for an Associateship of the R.A., having discussed his chances with Farington, who told him that the main objection to his works was 'their being unfinished'. He was not elected an Associate for another five years, aged forty-three (Turner had been elected A.R.A. twenty years earlier, at the age of twenty-four). He was elected full Academician, by only one vote against Francis Danby, ten years later in 1829.

It seems that on only two occasions paintings submitted by Constable for the summer exhibition were not accepted by the R.A. selection committee. In 1805, a view of Flatford Mill was refused; it was on this occasion that the President, Benjamin West, offered him advice Constable never forgot: 'remember light and shadow never stand still'. Most famously, his *Watermeadows at Salisbury* (plate 36) was rejected in unfortunate circumstances by the jury of 1830, of which he was a member. It was the first time he had sat on the committee, which selected works for the summer exhibition from the several thousand submitted by those who were not members of the R.A. Both Academicians and Associates were allowed to show up to eight paintings each without undergoing the selection process. Somehow *Watermeadows* was placed with the works to be vetted, and when it came before the jury, Constable's colleagues dismissed it, finding it 'too green' and, we may suppose, too sketch-like for an Academy exhibition. On realizing their mistake the committee wanted to reinstate it, but Constable would not allow it: 'It has been properly condemned as a daub', he was reported as saying, 'send it out'.

Constable was elected Visitor in the Life Academy for the first time during January 1831, when he was fifty-four. His biographer Leslie recorded that 'beginning with an Eve from Raphael [he] allowed no evening to pass without a short lecture addressed to the students'. When he gave a series of four lectures on the history of landscape painting at the Royal Institution in 1836, he prepared large copies of Renaissance paintings as teaching aids. Four are in the V&A; one is illustrated in the next chapter (plate 46).

His last address at the Royal Academy was on 25 March 1837, after teaching the last life class to be held in the old studios at Somerset House before the move to the new National Gallery building in Trafalgar Square. He referred to the R.A. as the 'cradle of British art', and reminded the

Plate 36. *Watermeadows near Salisbury*, 1829. Oil on canvas, 45.7 × 55.3 cms (18 × 21¾ ins).
FA 38 (R321)

students that even 'in the slightest pen and ink sketches of Raphael...you have the real principle of good drawing, – his figures live and move'. According to a newspaper report, his speech was much appreciated by his students, who 'arose and cheered most heartily'. It was to be his last lesson as he died within the week, during the night of 31 March. In this last speech, he may have been deliberately emulating the founding President of the R.A., Sir Joshua Reynolds, with his extolling of Raphael. In his last 'discourse' to the R.A., Reynolds desired 'that the last words which I should pronounce in this Academy...might be the name of Michelangelo'.

It is not easy to think of Constable in this company, to imagine the 'natural' painter of 'everyday' countryside admiring and discussing such Old Masters as Titian, Claude, and the Dutch painter Jacob van Ruisdael (1628–82). But he knew, like Reynolds, that certain artistic concerns permeate the centuries, and that some artistic achievements might be timeless.

Plate 37.
Detail from *Waterloo Bridge from Whitehall Stairs*, *c.*1819.
See plate 59.

CHAPTER 4

CONSTABLE AND THE OLD MASTERS

Richard Redgrave, the V&A's first curator of paintings as well as an accomplished painter in his own right, noted in *A Century of British Painters* (first published in two volumes by Smith, Elder & Co in 1866) that although:

Constable despised the painters who were content to see nature only through the eyes of others, it must not be presumed that he did not feel the merits of the great painters among the old masters, or was untouched by the beauty of their works. He was a great admirer of all that was truly good in landscape art.

Certainly Constable had a passionate interest in the works of the Old Masters, and they seem to have taken third place in his affections after his family and friends, and nature itself. He concluded a letter to his wife, written on 15 November 1821 from Salisbury, with the words: 'all my thoughts spite of Claude and Ruisdael are with you and my dear infants'.

The traditional teaching that Constable received at the R.A. imbued him with an appreciation of the work of the Old Masters. It was standard practice to learn by copying; it was learning by looking – closely looking rather than just seeing – and looking with intense concentration of eye and mind. Constable constantly refreshed his own personal experience of painting and drawing out-of-doors in the countryside, by thinking about how other artists in the past had achieved the effects he was seeking. It is interesting that he rarely seems to have looked closely at the work of his contemporaries: even Turner, his most important peer and sometimes rival, is rarely mentioned in his letters. But he was fascinated by images from the past, from the legacy of British landscape painting and the great tradition of Dutch, Flemish and Italianate art: works by Richard Wilson and Thomas Gainsborough in the eighteenth century, and back to Cuyp, Ruisdael, Rubens, Poussin and Claude, in the seventeenth.

It was not only the most celebrated and admired Old Masters that interested Constable. When he made his journey from London to Chatham in April 1803 (see p. 18), he was 'much employed in making drawings of ships in all situations', as he wrote to his friend John Dunthorne on 23 May. His secondary inspiration, after the sights themselves, was the work of the Dutch painter William van de Velde the younger (1633–1707), who had worked a great deal in London. According to an entry made by Farington in his diary on 21 May 1803, Constable had told him that he did not think Turner's pictures 'true to nature...like the works of van de Velde'.

Constable had been introduced to the work of Claude and Ruisdael before he entered the R.A. Schools in 1800. These two seventeenth-century artists exerted a decisive influence on his own theory and method of painting throughout his life, especially Claude's subtle treatment of light and colour and mastery of pictorial composition, and Ruisdael's rugged atmospheric effects and outdoor naturalism. Constable's experience of Claude's work was solely due to his meeting with Sir George Beaumont. Patron, collector and amateur artist, Beaumont is most remembered today for his generous friendships with several contemporary artists, and even more for his gift of sixteen pictures to the British nation which led to the foundation of the National Gallery in London. Beaumont had learned drawing from Alexander Cozens at school at Eton College, and in 1782–3 made the customary year-long Grand Tour of Europe, spending most of his time – unlike his contemporaries – sketching in and around Rome. Beaumont knew both Sir Joshua Reynolds and Richard Wilson, the principal propagandists for painting great subjects in a classical style based on the examples of seventeenth-century masters. Of these, Claude's idyllic landscapes populated by historical, mythical or Biblical characters, constructed with strict formality and bathed in the golden light of the Roman Campagna, were the most admired in England. Wilson, for example, said that all he had learned of painting was from looking at Claude.

When Beaumont was in Rome, he tried unsuccessfully to purchase a Claude from the great Barberini family collection. But back in London, in 1785, he was able to buy Claude's small *Hagar and the Angel* (plate 38) at an auction, and it became his favourite painting in his collection. For him, as for others who made the Grand Tour, Claude's pictures provided a permanent reminder of the special beauties of the landscape of Italy. On meeting Constable in Dedham in 1795, Beaumont was shown some large drawings the young artist had just made, copied from engravings by Dorigny after two of Raphael's Sistine tapestry cartoons. In return, Beaumont showed Constable his painting by Claude, which he always carried with him whenever and wherever he travelled.

In the same year that Constable saw Beaumont's *Hagar and the Angel*, he made a copy in sepia ink of another painting by Claude, which has not been identified. Since it was a copy, it could now be in a collection under a name other than Constable's. Joseph Farington recorded in his diary on 29 May 1800 that Constable was copying the *Hagar* itself at Beaumont's country

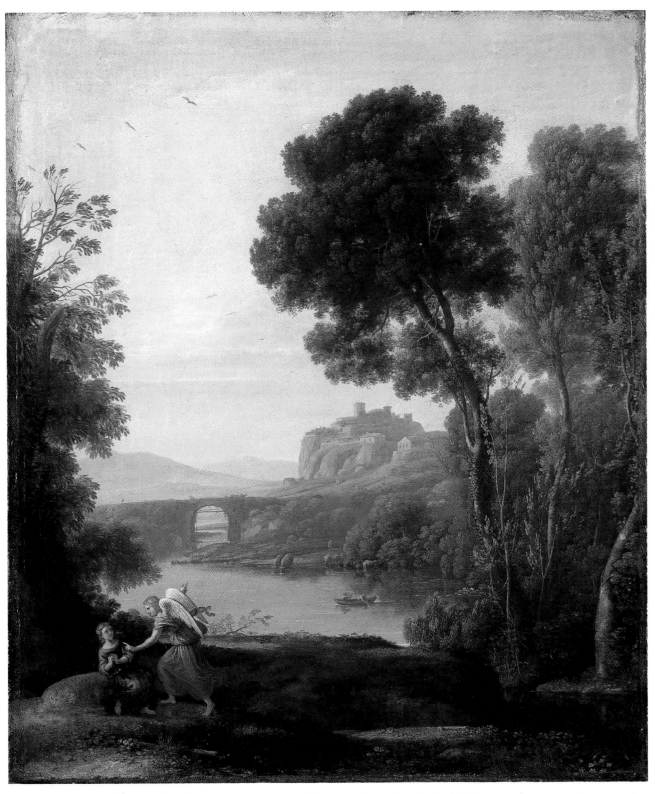

Plate 38. Claude (Claude Gellée, le Lorrain, 1600–82), *Hagar and the Angel*, 1646. Oil on canvas mounted on wood, 52.7 × 43.8 cms (20¾ × 17¼ ins). Bought by Sir George Beaumont in 1785. When he gave his collection to the National Gallery, he stipulated that the Claude – his favourite – should remain with him until his death. Constable copied it in about 1800; the whereabouts of this copy is now unknown. National Gallery (61)

Plate 39. *Dedham Vale*, 1802. Oil on canvas, 43.5 × 34.4 cms (17⅛ × 13½ ins). Based on Claude's
Hagar and the Angel, the composition is in turn the basis of Constable's 1828 R.A. exhibit. The view is
from near Gun Hill, looking towards Dedham village with the estuary of the River Stour in the distance.
124–1888 (R37)

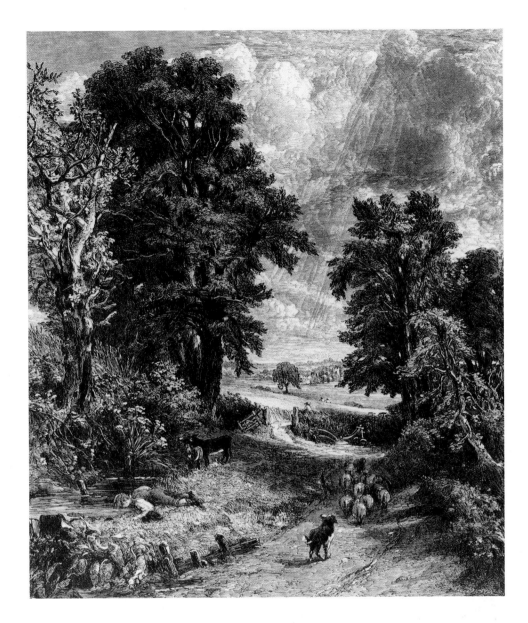

mansion at Coleorton, and Constable went on to adapt the composition for his own *Dedham Vale* of 1802 (plate 39). He used the composition again on several occasions, notably in *The Cornfield* of 1826 (plate 40), and his devotion to the image reached its apotheosis in the magnificent 1828 *Dedham Vale* (plate 41). As a coda to the development of his fascination with Beaumont's Claude, one of Constable's last watercolours (plate 27) echoes its basic compositional structure.

Beaumont and Constable became good friends, and on 21 October 1823 Constable wrote to his wife Maria from Coleorton: 'Oh dear this is a lovely place...only think that I [am] now writing here in a Room full of Claudes...real Claudes...almost at the summit of my earthly ambitions'. On that visit he copied a small painting by Claude, a sunset, and wrote again to

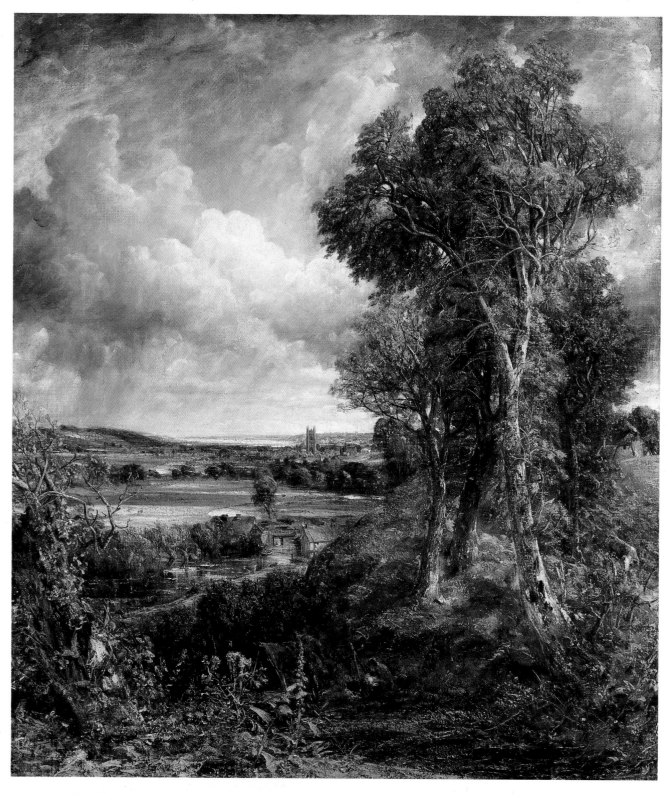

Plate 41. *Dedham Vale, c.*1827. Exhibited at the R.A. 1828. Oil on canvas, 145 × 122 cms (57⅛ × 48 ins). This painting is the culmination of Constable's interest in Claude's *Hagar and the Angel*, and was possibly prompted by Beaumont's death in 1827. It shares the scintillating light and sparkling touches of pure pigment of the great series of canal scenes. National Gallery of Scotland, Edinburgh (2016)

Maria on 5 November: 'I have slept with one of the Claudes every night – you may indeed be jealous'. Also during that stay he made drawings of two of the monuments erected by Beaumont in the grounds of Coleorton. The first was a simple uncarved stone dedicated to the memory of Richard Wilson (plate 42). The other was more elaborate: a cenotaph commemorating Sir Joshua Reynolds, inscribed with lines written by the poet William Wordsworth (who visited Coleorton), and set in an opening surrounded by lime trees, giving the effect of an arboreal chapel. This drawing (plate 43) was the basis of the large picture painted between 1833 and 1836 – exhibited at the R.A. in 1836 – in which the cenotaph is flanked by two busts, displayed on stone plinths, depicting Raphael and Michelangelo. The painting was Constable's last oil

Plate 42.
A stone dedicated to Richard Wilson in the grove of Coleorton Hall, 1823. Pencil and grey wash, 26.2 × 18.1 cms (10¼ × 7⅛ ins). Inscribed by the artist on the back 'Stone in the Grove Coleorton Hall. Dedicated to the Memory of Richard Wilson. Novr. 28. 1823'. From a sketchbook which includes two other Coleorton drawings: another view of the Wilson stone, and one of the Reynolds cenotaph (plate 43).
815–1888 [R260]

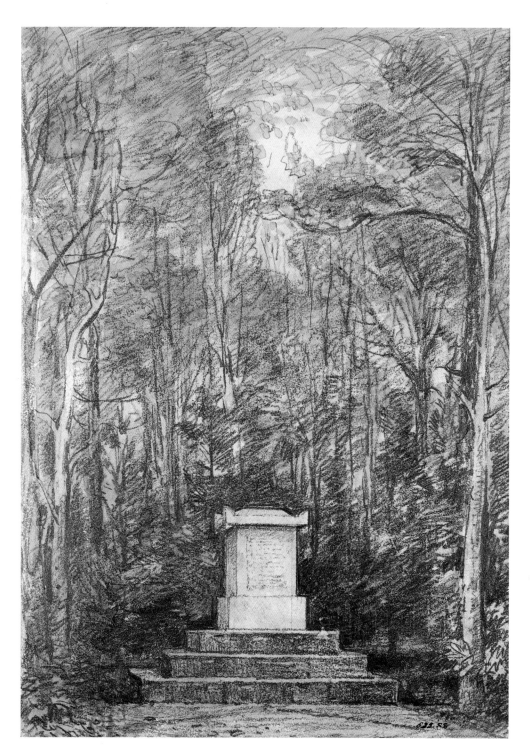

Plate 43.
*The Cenotaph to Sir
Joshua Reynolds
amongst lime trees in the
grounds of Coleorton
Hall*, 1823. Pencil and
grey wash, 26 × 18.1 cms
(10¼ × 7⅛ ins).
Inscribed by the artist on
the cenotaph with lines
by Wordsworth and on
the back 'Coleorton Hall.
Novr.28.1823'.
835–1888 [R259]

to be shown at the Academy during his lifetime, and the exhibition was the last R.A. exhibition to be held at Somerset House. In 1888 the painting was given by his family to the National Gallery, where it can be seen today. Beaumont had died in 1827, and this painting may be considered a fitting tribute on the part of Constable to his friend and mentor. The full title of the painting in the 1836 R.A. catalogue was *Cenotaph to the memory of Sir Joshua Reynolds, erected in the grounds of Coleorton Hall, Leicestershire, by the late Sir George Beaumont, Bart.*, followed by a quotation from Wordsworth's poem. This lengthy title was deliberate: Constable wrote to a friend that he wanted to see both the names of Reynolds and Beaumont 'once more in the catalogue, for the last time in the old [Somerset] house'.

When the French art critic Charles Nodier saw Constable's *The Hay Wain* at the R.A. exhibition of 1821, he wrote of how the artist's work needed to be seen from a distance, adding 'it is water, air and sky; it is Ruisdael, Wouwermans, or Constable'. Philip Wouwermans (1619–98) and his brothers Jan (1629–66) and Pieter (1623–82) were Dutch landscape painters much admired both in Holland and throughout Europe. The work of the Dutch painter Jacob van Ruisdael (1628–82) was more popular in England, however, than anywhere else in Europe. He specialised in densely wooded landscapes with forest paths, enlivened by windmills, watermills and sometimes cloud forms in extensive skies, although one of the principal features of Ruisdael's art, particularly evident in his etchings (of which there are many), was the way massive trees in full leaf could dominate the composition, often leaving little room for a view to the sky. Some of Constable's drawings share a similar quality (plate 92). Constable was introduced to Ruisdael's work by one of his earliest artist friends, John Thomas Smith, whom he met in 1796. An engraver, topographer, drawing master and author, Smith showed the young Constable some Ruisdael etchings which Constable asked permission to borrow and copy, although 'as they are very scarce and dear, perhaps you would not like to trust them' (letter of 16 January 1797). In London in 1799, soon after he entered the R.A. Schools, he first saw paintings by Ruisdael, and with the artist Ramsay Richard Reinagle, who was the same age and with whom for a brief time he shared lodgings, even purchased a Ruisdael picture for £70 and copied it. He sold the original in 1801.

Constable's admiration for Ruisdael was lifelong; for example he copied a landscape with a windmill in the Dulwich Picture Gallery in 1831, and a

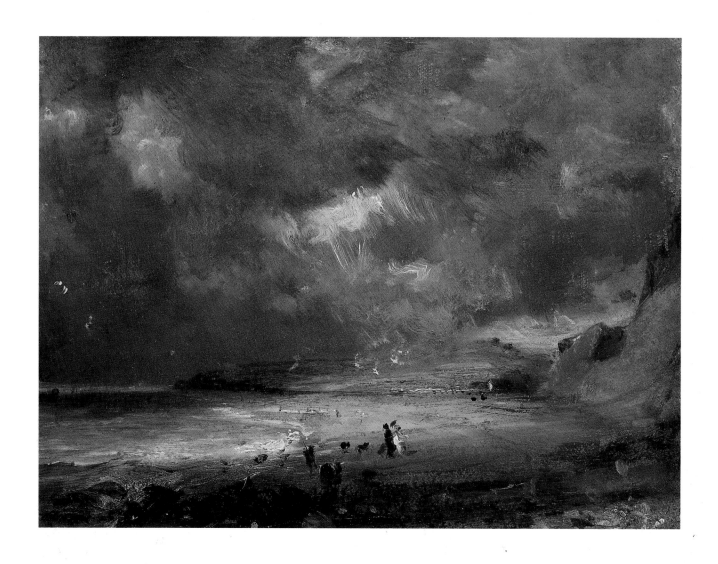

Plate 44. *Weymouth Bay (Bowleaze Cove)*, 1816. Oil on board, 20.3 × 24.7 cms
(8 × 9¾ ins). Inscribed by the artist with the monogram 'JC' on the back.
330–1888 [R155]

winter scene in Sir Robert Peel's collection in 1832. The composition of Constable's famous *Weymouth Bay* of 1816 (plate 44) is loosely based on Ruisdael's *Shore at Egmond-aan-Zee* (plate 45), now in the National Gallery, of which Constable must have seen a print. He also praised Ruisdael in his letters and his 1836 lectures. On 26 November 1826, for example, he wrote to John Fisher of 'an affecting picture' by Ruisdael that he had seen that morning in an art dealer's showroom: 'it haunts my mind and clings to my heart...it is a watermill; a man and boy are cutting rushes in the running stream...the whole so true, clean, and fresh, and as brisk as champagne; a shower has not long passed'.

In the third of his four lectures to the Royal Institution, 'The Dutch and Flemish Schools' given on 9 June 1836, Constable pronounced that:

The landscapes of Ruisdael present the greatest possible contrast to those of Claude...in Claude's pictures, with scarcely an exception, the sun ever shines. Ruisdael, on the contrary, delighted in, and has made delightful to our eyes, those

Plate 45.
Jacob van Ruisdael
(1628/9?–82), *Shore at Egmond-aan-Zee*, c.1675.
Oil on canvas,
53.7 × 66.2 cms
(21 1/8 × 26 1/6 ins). Since this painting did not enter a British collection until 1846, Constable could not have seen the original. However, he may have known the composition through a copy or similar picture; there was an engraving, but in reverse. National Gallery (1390)

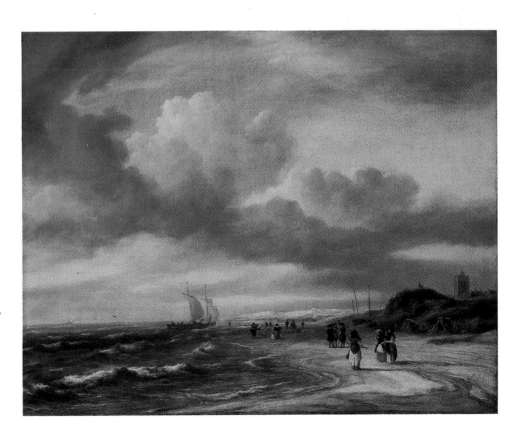

solemn days, peculiar to his country and ours, when without storm, large rolling clouds scarcely permit a ray of sunlight to break the shades of the forest. By these effects he enveloped the most ordinary scenes in grandeur.

This passage, particularly the last sentence, could be a comment on much of Constable's own work.

As an illustration to the first of the 1836 lectures, Constable made a large sepia sketch after a drawing by Titian for his great altarpiece of *The Death of St Peter Martyr* (painted for the church of Santi Giovanni e Paolo in Venice in 1530, destroyed by fire in 1869, and known now only through a woodcut and painted copies). The drawing had belonged to Sir Thomas Lawrence, an eminent collector as well as a successful portrait painter; after his death in 1830, the drawing was bought by the leading art dealers of the day, the Woodburn brothers. Presumably Constable copied the drawing in their gallery. For the lecture, Constable also borrowed a copy of the altarpiece made by the young portrait painter John Partridge. The altarpiece was important in the history of European landscape painting because of the vivid depiction of the background trees and sky. Constable ended his lecture with a long panegyric on the picture, believing that its landscape background 'although not the model, may be considered as the foundation of all the styles of landscape in every school of Europe in the following century'. He admired Titian's truth to nature – 'every touch is the representative of a reality' – and returned to comment on Titian in each of the following three lectures. Constable's sepia sketch shows only the foreground figure of the dying St Peter; there is no indication of the background. Presumably he used the Partridge copy to eulogize Titian's landscape. This reminds us that Constable continued to attend the Life Class at the Royal Academy throughout his life and that, although (like Turner) he is sometimes derided for the inadequacies of the figures in his paintings, he retained a respect for that aspect of pictorial art.

His interest in the work of the Italian Old Masters extended back even beyond Titian. Three other large sepia drawings in the V&A collection made as illustrations to his 1836 lectures are copies of engravings after a fifteenth-century fresco by Paolo Uccello (1397–1475), an early fourteenth-century sculpture then ascribed to Nicola Pisano (c.1220–83), and one of the frescoes in the Campo Santo in Pisa thought then to be by Giotto (1266/7–1337) (plate 46). Of the last, he told his audience:

Plate 46.
Job and his friends,
c.1836. Grey wash,
100.5 × 141.5 cms
(39½ × 55¾ ins).
Constable made this
drawing to illustrate his
first lecture on the history
of landscape at the Royal
Institution in 1836. It is
presumably copied from a
print in Carlo Lasinio's
volume of engravings after
the celebrated frescoes in
the Campo Santo at Pisa.
D.1875–1908 [R399]

It was fortunate, therefore, for landscape, destined as it was to become so material a feature of the art, that it originated and was in its infancy nursed in the hands of men who were masters of pathos. As early, I believe, as Cimabue [*c*.1240 – after 1302], and certainly Giotto, landscape became impressive. I am told that in the Campo Santo at Pisa, the frescoes exhibit wonderful proofs of its use and power.

Although at the time of Constable's lectures in the 1830s the R.A. officially still considered landscape inferior to other subjects for painting, attitudes in the wider world of art, and particularly among collectors, were rapidly changing. Constable's admiration for the art of the past was never abject and always constructive, and it never conflicted with his confidence in his avowed intent to be a 'natural painter'.

CHAPTER 5
CONSTABLE'S METHOD
OF WORKING

Constable, like his predecessors and contemporaries, considered the 'end product' for which his training and talent had prepared him was the 'finished' picture, either commissioned by a patron or to be exhibited at the R.A. summer exhibition and, it was to be hoped, sold to a private collector or an art dealer. Although his financial security was such that he had less need to find purchasers and patrons for his work than most professional artists, Constable was concerned nevertheless to sell his paintings, both to raise his public status and for his personal satisfaction.

Behind the 'finished' exhibited painting was what Whistler was to call 'a lifetime of experience': in practical terms, there were many sketches and studies by Constable often made on-the-spot in the open air. For Constable, constant refreshment in the form of study out-of-doors was essential to his working method. Unlike most nineteenth-century landscape painters, who with luck would settle early in their careers on a winning formula, Constable was always re-thinking and re-examining his aims. This has to be due to his intense experience from a young age of the countryside around East Bergholt: 'The world is wide', he wrote, 'no two days are alike, nor even two hours; neither were there ever two leaves of a tree alike since the creation of the world; and the genuine productions of art, like those of nature, are all distinct from each other.'

Plate 47.
Shipping in the Thames,
1803. Pencil, grey wash and watercolour,
19.3 × 31.6 cms
(7½ × 12⅜ ins).
808–1888 [R44]

Plate 48.
Cottages at East Bergholt
(two drawings on the
same sheet), 1796.
Pen and ink,
14.3 × 17.9 cms (5⅝ × 7 ins)
and 15.5 × 17.9 cms
(6 × 7 ins). Both inscribed
by the artist at the top
'E Bergholt Suffolk'.
358e and 358f [R7 and 8]

Plate 49.
*A page from a
sketchbook*, 1813.
Pencil, 8.9 × 12 cms
(3½ × 4¾ ins).
317–1888
[R121, page 46]

The first stage of Constable's work took place in the sketchbook, the drawings usually made in pencil – not the easiest but the most portable medium. Most of the sketchbooks used by him, like those by other eminent artists, have been dismantled over the years, often for commercial reasons; there are many loose sheets from Constable's sketchbooks in the V&A, presumably broken up by the artist himself, or by his family. This is sometimes visually clear from the format of the sheet (plate 48), but often a page from a sketchbook is only identifiable from the watermark in the paper (plate 47). The 1803 drawing *Shipping in the Thames* bears the watermark 'T Wickwar 1801', for example, and is about the same size as another sheet in the V&A and further drawings in other collections, all bearing the same watermark. But there are three intact sketchbooks in the V&A, all given by Isabel Constable in 1888, dating from 1813, 1814 and 1835. These provide the fullest and the most intimate contact with Constable's eye and mind.

In late March 1814 Constable wrote to his wife-to-be Maria about a large painting he had almost finished for the R.A. summer exhibition, ending the letter: 'You once talked to me about a journal. I have a little one that I made

Plate 50.
A page from a sketchbook,
1814. Pencil,
8 × 10.8 cms (3⅛ × 4¼ ins).
1259–1888 [R132, page 9]

Plate 51. *Study of foliage,* 1820–30. Oil on paper, 15.2 × 24.2 cms (6 × 9½ ins).
338–1888 [R326]

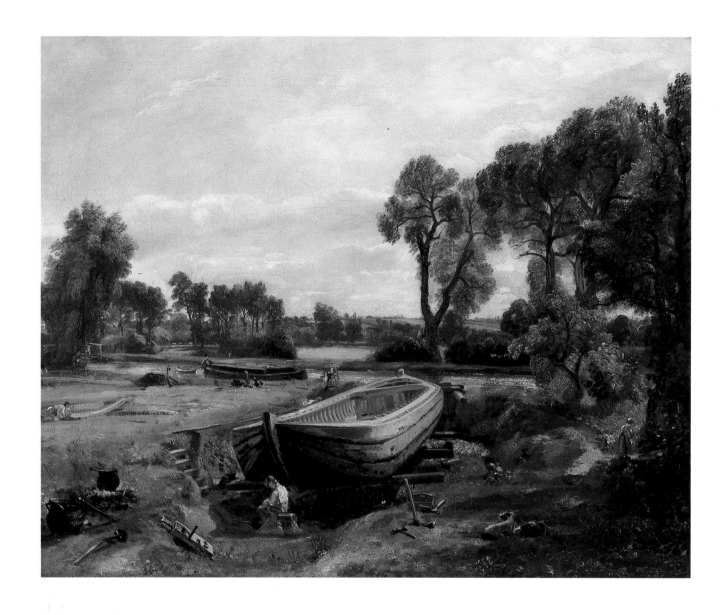

last summer that might amuse you could you see it – you will then see how I amused my leisure walks, picking up little scraps of trees, plants, ferns, distances etc. etc.'. As was his usual routine, he had spent the summer of 1813 in East Bergholt, from 30 June to early November. There he was able to look at nature in the countryside he knew well, but where he was always finding something new. The little journal he mentioned to Maria must be the 1813 sketchbook now in the V&A. Its ninety pages of Whatman paper are watermarked with the date 1810, and are half-bound in black leather and gold tooled with marbled end boards. There are seventy-two pages of sketches, dating between 10 July and 22 October. Using the book in Essex and Suffolk, Constable drew studies of buildings, animals and figures, and composition sketches, sometimes placing four or five on one page (plate 49).

Constable was again in Suffolk between April and November 1814,

although he visited London for occasions such as the opening of the R.A. exhibition. He wrote to Maria on 4 May that he had taken 'several beautiful walks in search of food for my pencil this summer when I hope to do a great deal in landscape'. The summer and autumn weather in 1814 was very fine: he wrote again to Maria on 18 September, saying that: 'this charming season...occupies me entirely in the fields and I believe I have made some landscapes that are better than usual with me...I can hardly tell you what I feel at the sight from the window...of the fields in which we have so often walked'.

He also kept another visual journal, a slightly smaller-sized sketchbook of eighty-four pages, with fifty-eight bearing pencil drawings. Of these, two are of special interest. Page nine has a study of dock leaves (plate 50) which is similar to an oil sketch of the 1820s (plate 51), and of the kind that appears over and over again in the foreground of his larger oil paintings such as *The Leaping Horse* (plate 61). But there are a larger number of compositional studies clearly intended to be worked up into finished oil paintings. The most

Plate 53.
A page from a sketchbook,
1814. Pencil, 8 × 10.8 cms
(3⅛ × 4¼ ins).
1259–1888 [R132, page 57]

famous pages for us today are the three which show his first thoughts for the oil painting exhibited the following year, *Boat-building near Flatford Mill* (plate 52). The left-hand page has small, very rapid sketches of the men working on the boat, the seated boy, and the cauldron containing the pitch and ladle; the right-hand page shows the whole composition in embryo (plate 53). This page is dated 'Sepr.7.1814. Wednesday'.

The scene of a barge under construction would be very familiar to Constable, especially as the dry dock was owned by his father. As Michael Rosenthal so evocatively has written: 'we see first a figure engaged on a baulk, then, next him, but closer, a second working on shaped timber. The viewpoint is so high as to let the eye prospect the interior of the barge under construction, and understand how it is made'.

Unusually, Constable does not seem to have made any intermediate sketches before embarking on the finished painting, and there are no known oil studies. This is probably (and the principal interest of the painting for us today) because it is thought to have been painted entirely out-of-doors rather than in the artist's studio. C. R. Leslie recorded that Constable had told him this. But, as discussed earlier in this book, Constable also learnt from the Old Masters. Farington recorded in his diary on 23 July 1814:

I recommended to him to look at some of the pictures of Claude before he returns to his country studies, and to attend to the admirable manner in which all parts of his pictures are completed. He thanked me much for the conversation we had, from which he said he should derive benefit.

Taking his advice, Constable looked at paintings by Claude in the Angerstein collection (now in the National Gallery). Claude's principal lesson for Constable was the diaphanous, silvery-green light and atmosphere. The process of painting *Boat-building* is fully described by Sarah Cove in the 1991 Tate Gallery exhibition catalogue, but it is interesting to note here that the only underdrawing on the smallish canvas is a single pencil line indicating the shape of the top of the central barge. It was the first layer of paint that gave the basic structure of the composition, with the second layer of thicker and brighter pigments providing the details of foliage and plants, figures and implements. Constable also simplified the composition from the small pencil sketch, reducing the number of figures; one figure, stirring the cauldron of pitch at the left, was painted out at a late stage and is visible only with x-ray photography.

19th July 1835. Arundel. dear Minna's birthday.

Plate 54.
A page from a sketchbook,
1835. Pencil,
11.5 × 18.8 cms
(4½ × 7⅜ ins). Inscribed by
the artist bottom left '19th.
July 1835. Arundel – dear
Minna's birthday'.
316–1888 [R382, page 33]

Boat-building was among eight works (the maximum permitted to be shown by one artist) in the 1815 R.A. summer exhibition. Robert Hunt, art critic for the *Examiner* newspaper and also a landscape painter himself, wrote in the 28 May issue that 'it is a pity that Mr Constable's pencil [that is, paintbrush] is still so coarsely sketchy. There is much sparkling sunlight, and a general character of truth...in *Boat-building*.' The *New Monthly Magazine* of 1 July commented that

In Mr Constable's landscapes there is a constant reference to common nature, seen in the freshness of his trees and his colouring in general; but we cannot help regretting that his performances, from want of finish, are rather sketches than pictures...Boat-building, we think his best picture; the boat is most happily placed, and the whole composition highly pleasing and natural.

The other intact sketchbook in the V&A collection, dating from 1835, is the latest in date in existence anywhere. Larger in size than the 1813 and 1814 books, it consists of fifty pages, twenty-five of which bear drawings in pencil, pen and ink, and watercolour. A fine pencil drawing of Arundel Castle dated 19 July 1835 (plate 54) became the basis of the oil painting exhibited at the R.A. in 1837 and now in the Toledo Museum of Art, Ohio.

A similarly practical medium for use out-of-doors is watercolour, requiring only a small, easily portable box of colours and a sketchbook, or a drawing board to which a sheet of paper would be pinned. Constable, like Turner,

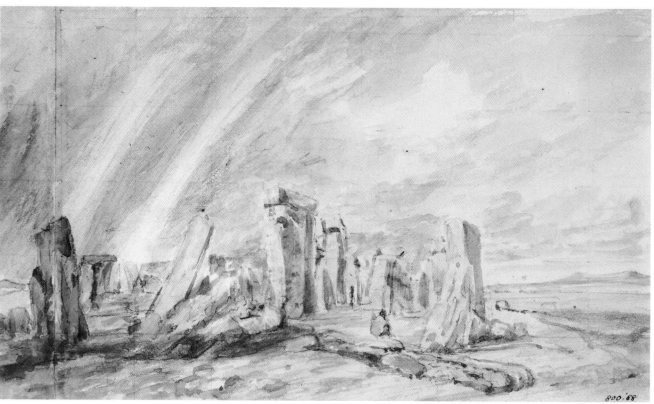

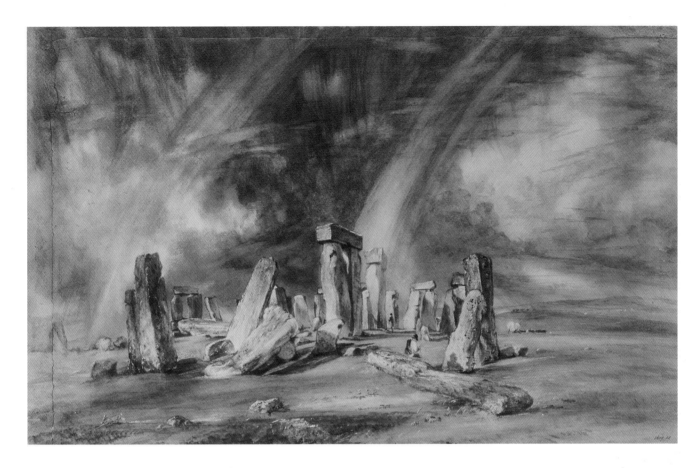

Plate 57.
Stonehenge, 1835.
Exhibited at the R.A. 1836.
Watercolour,
38.7 × 59.1 cms
(15¼ × 23¼ ins).
1629–1888 [R395]

Plate 55. *(left, top)*
Stonehenge, 1820. Pencil,
11.5 × 18.7 cms
(4½ × 7⅜ ins). Inscribed by
the artist bottom left
'15 July 1820' and on the
back 'Stone Henge'.
309–1888 [R186]

Plate 56. *(left, bottom)*
Stonehenge, probably 1835.
Pencil and watercolour,
lightly squared in pencil
for enlargement,
15.4 × 25.3 cms (6 × 10 ins).
800–1888 [R396]

also painted watercolours which were not studies for later works in oil, but intended as works of art in their own right and to be exhibited in public. In the V&A collection, the most notable are the magnificent *Old Sarum* and *Stonehenge* (plate 57).

Despite his several visits to Salisbury, there is only one recorded excursion to nearby Stonehenge, on 15 July 1820. On this occasion he made a pencil drawing (plate 55) which was to be the basis of his watercolour, painted fifteen years later. The drawing – made, of course, on the spot – is a straightforward account of the structure of the stones. Why Constable returned to the subject in 1835 is unclear, but he was to transform the simple pencil drawing into one of the greatest watercolours in the history of art. In preparation, he made another sketch and two watercolours, all of which are squared up for enlargement. The V&A watercolour (plate 56) shows how Constable is working his imagination on the stormy sky and the spectacular double rainbow.

So far in this story, Constable has conformed for the most part to traditional methods of working, aiming at an oil painting to be exhibited in public and sold to an eminent collector. But he departed from tradition in two ways. First, he early made a habit of making oil sketches on paper or millboard in the open air. These were of various sizes, though most were

approximately 18 cms × 25 cms (7 ins × 10 ins). They were only on occasion intended as studies for projected oil pictures: sometimes they were paintings in their own right.

The second, and more dramatic, innovation was his practice of making a full-size oil sketch for the largest of his exhibition pictures – the so-called 'six-footers'. This practice began in 1818, with the sketch for *The White Horse* now in Washington's National Gallery of Art, and the finished painting of the same size exhibited at the R.A. in 1819 and now in the Frick Collection, New York. Constable had always found it difficult to reconcile the freshness of personal experience of nature in the open air with producing an acceptable composition in 'Old Master' terms, which meant exhibiting a painting of a size and stature that would command public attention either at the R.A. and/or the British Institution. (The British Institution was an exhibiting gallery that specialised in contemporary landscape painting and loan exhibitions of Old Master pictures.) With the series of 'six-footers', each exhibited and each prepared by a full-size sketch, Constable to a great extent resolved this problem. As Leslie recorded, *The White Horse* was 'too large to remain unnoticed' and 'attracted more attention than anything he had before exhibited'.

The full-size oil sketch was a way of testing the composition at scale, achieving the desired balance of lights and dark, and determining which details were necessary and which were not. In the full-size sketch for *The Hay Wain* (plate 17), for example, a boy seated on a horse appears next to the dog in the foreground. This detail survived into the finished picture, but was painted out at a late stage. As the top paint surface has become more transparent over the years, the ghosts of the boy and horse are now faintly visible to the naked eye.

Likewise, in the full-size sketch for *The Leaping Horse* (plate 61), Constable evidently wanted to balance the powerful curve of the leaping horse itself with an answering curve immediately ahead in the form of a truncated willow tree. In the 'finished' painting for the R.A. summer exhibition, he moved the tree to almost the exact centre of the composition. This is not entirely satisfactory: the tree isolates rather than unites the left and right halves of the painting. The other decisive change takes place on the left, where the two barges, one only seen in part with the bargee wielding his pole, are replaced by one, more prominent because of its mast and unhoisted sail.

The whiteness of the sail serves to balance the brilliant white of the reflections in the surface of the river on the right. But however disturbing the central tree might be to the eye, the whole composition is bound together in the exhibited version by the brilliance of the sky, which dominates most of the upper part of the canvas and inhabits through flickering reflected light the great mass of trees on the left. The use of the words 'exhibited version' may be misleading, however. Constable wrote to Fisher on 23 January 1825:

the large subject [*The Leaping Horse*] on my easel is promising; it is a canal, and full of the bustle incident to such a scene where four or five boats are passing in company; with dogs, horses, boys and men and women and children, and best of all, old timber-props, water plants, willow stumps, sedges, old nets, etc.

He wrote again to Fisher on 8 April, noting that he had submitted the painting to the R.A. but that it was still unfinished: 'it is a lovely subject, of the canal kind, lively – and soothing – calm and exhilarating, fresh – and blowing, but it should have been on my easel a few weeks longer'.

Given the usual manner of hanging pictures at the R.A. and other exhibitions (plate 28) in the eighteenth and nineteenth centuries, artists competed for visual attention to a degree unthinkable today. Just before the public opening of R.A. summer exhibitions, artists were given the opportunity to improve and amend their work on the so-called 'Varnishing Day'. This enabled artists to see their works hanging in place on the wall, and to adjust colours and the degree of varnish in response to a new physical context: probably to a different quality of light from that in their studios, and to other paintings displayed in close proximity. The varnishing day before the 1832 exhibition was the occasion of a confrontation between Constable and Turner.

Although almost exact contemporaries – Turner was just over a year older than Constable – they were never truly rivals as their aims and styles were so markedly different. In earlier years, Constable had criticised Turner as 'more and more extravagant, and less attentive to nature', calling his 1812 *Hannibal Crossing the Alps* (Tate Gallery) 'so ambiguous as to be scarcely intelligible', but in his later years he wrote of Turner's 'golden visions, glorious and beautiful...one could live and die with such pictures'. At the R.A. exhibition of 1832, Constable's *The Opening of Waterloo Bridge* (Tate Gallery), which pulsates with splashes of red and white, was hung alongside Turner's pale grey seascape *Helvoetsluys* (Indiana University Art Museum).

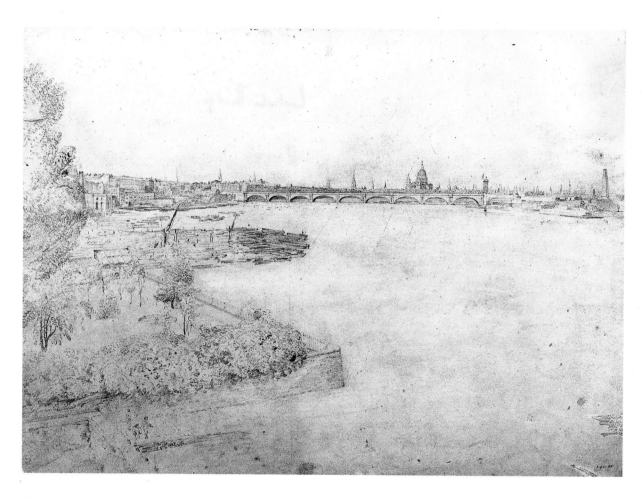

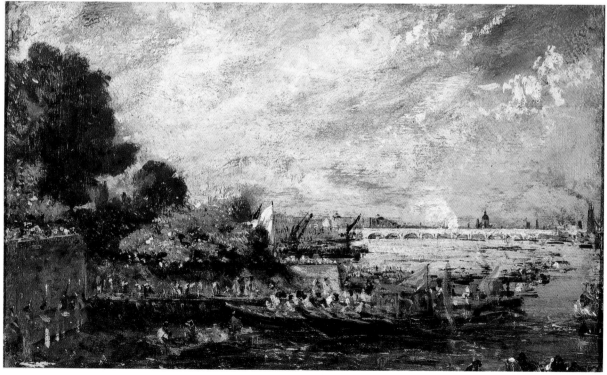

Plate 60.
The Thames with Waterloo Bridge, c.1819.
604–1888 [R175]

On varnishing day, Turner added a brilliant red floating buoy to his painting: Constable said that 'he has been here and fired a gun'. The year before Constable had been a member of the hanging committee for the summer show. Turner chose to submit his *Manby Apparatus* (V&A) in direct competition with Constable's similar subject *Yarmouth Pier* (present whereabouts unknown); at the same exhibition Constable replaced a Turner painting (possibly the *Manby Apparatus*), which hung in an excellent position, with his own *Salisbury Cathedral* (the version now in the National Gallery). The painter David Roberts recorded that 'Turner was down on him like a sledgehammer'.

The progress of two other projects may be followed through the V&A collections. The first begins with the drawing of the view across the Bishop's grounds to Salisbury Cathedral, made during Constable's first visit in 1811 and used for the celebrated picture painted, and exhibited at the R.A., twelve years later (plates 63, 64, 65 and 66). These are discussed further in the next chapter. The second, and perhaps the fullest sequence of works, is the series of studies for *The Opening of Waterloo Bridge*. He began this painting in 1817 but experienced many difficulties which delayed completion until the exhibition of 1832, cited above. The subject was the official opening of the new bridge by the Prince Regent (later George IV) on 18 July 1817; not the kind of subject normally associated with Constable. He wrote to John

Plate 58. *(left, top)*
Waterloo Bridge from above Whitehall Stairs, c.1819.
290–1888 [R173]

Plate 59. *(left, bottom)*
Waterloo Bridge from above Whitehall Stairs, c.1819.
322–1888 [R174]

Fisher in 1819: 'I have made a sketch of my scene on the Thames – which is very promising'. The opening, which Constable witnessed and presumably sketched on the spot, was an event of great pomp and ceremonial, which must have been one cause of Constable's difficulties. The earliest known drawing seems to date from 1819, a careful pencil study of the view along the Embankment towards the new bridge seen from an upper window of a house in Whitehall Yard (plate 58). The house itself is shown in the left foreground of the finished painting (now in the Tate Gallery). This was followed, probably in the same year, by an oil sketch (plate 59) and a pen and ink drawing (plate 60). The oil sketch is stunningly free in handling, with evidently rapid strokes of pure colours, especially red and white. As with *The Hay Wain* and *The Leaping Horse* (plates 17 and 61), he determined to preserve the freshness and brightness of the sketch in the finished painting.

This may be the most similar quality Constable shared with Turner: the desire and ability to present for exhibition paintings that appeared spontaneous. It was this quality that bemused and lacked appeal for many of their contemporaries – fellow artists, critics and public alike – but which we now admire and cherish.

Plate 61.
Fullsize sketch for 'The Leaping Horse', c.1825. 986–1900 [R286]

CHAPTER 6
SALISBURY AND THE FISHER FAMILY

Constable's closest friends were the Fisher family: John Fisher, appointed Bishop of Salisbury in 1807, his wife Dorothea, their children Edward, Elizabeth and Dorothea (to whom Constable gave drawing and painting lessons) and – especially – their nephew, another John. The younger John Fisher was to become Archdeacon of Berkshire and, more importantly for us today, Constable's principal confidant in the form of correspondence (plate 62). Many of Constable's most intimate thoughts and feelings were expressed in letters to his friend. In 1821, for example, he wrote: 'I shall never be a popular artist – a Gentlemen and Ladies painter...but I look to what I possess and find ample consolation', and in 1826 he commented 'you once said – "life is short – let us make the most of friendship while we can"'. It was C.R.Leslie's observation that Constable's life work constituted 'a history of his affections', and certainly his few excursions outside his homes in East Bergholt and Hampstead were more often than not related to his deep affection for the Fishers of Salisbury.

Plate 62.
Portrait of Archdeacon John Fisher, 1816. Exhibited at the R.A. 1817. Oil on canvas, 35.9 × 30.3 cms (14 × 11⅞ ins). Constable's closest friend, Fisher hosted the artist and Maria for six weeks, during their honeymoon, at his vicarage in Dorset. This portrait, and that of Fisher's wife Mary (also in the Fitzwilliam Museum), were painted during the visit. Fitzwilliam Museum, Cambridge.
PD.44–1972

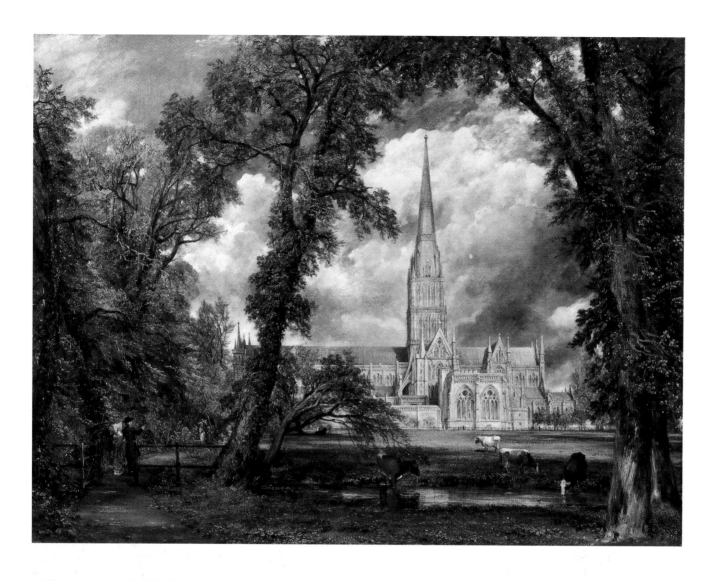

The artist probably first met Bishop Fisher (1748–1825) as early as 1798, meeting the younger John Fisher during his first visit to Salisbury in 1811. Constable's two principal visits to Salisbury were for several weeks in 1820 and 1829, and resulted in some of his most celebrated paintings. The culmination of his love of the city was the series of views of the cathedral in and around the Close, especially that painted for the Bishop in 1823 (plates 63 and 64).

Although Constable's methods of working have been dealt with in the previous chapter, it seems appropriate here to follow the process of construction that led to the famous *Salisbury Cathedral from the Bishop's Grounds*, commissioned by Bishop Fisher himself and exhibited at the R.A. in 1823. The earliest drawings were made in pencil during Constable's first visit to Salisbury. There are three small studies: one of the cathedral's exterior seen from the south-east, dated on the back 30 September 1811 (plate 65), and the others depicting the west front and the east end. The dated

Plate 63.
Salisbury Cathedral from the Bishop's Grounds, 1823. Exhibited at the R.A. 1823. Oil on canvas, 87.6 × 111.8 cms (34½ × 44 ins). Inscribed indistinctly 'John Constable A.R.A London 1823'. FA 33 (R254)

Plate 64. *(right)*
Salisbury Cathedral from the Bishop's Grounds (detail), 1823.

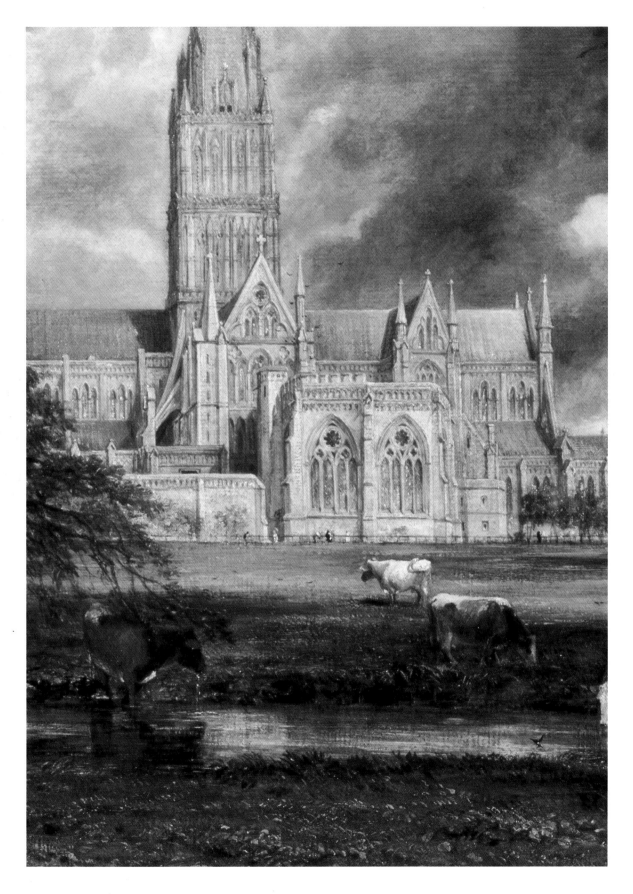

drawing shows the view from the grounds of the Bishop's Palace, looking past one wall of the octagonal Chapter House towards the side of the great west front. The view is taken from a different angle from that of the more famous drawing (plate 66), which was to form the compositional basis for the later paintings in oil, but the small tree and the larger horse-chestnut tree are recognisable in both.

Bishop Fisher had a distinguished career and was a favourite of George III, enjoying various court posts and patronage; on meeting him in Italy Mrs Piozzi, the famous friend of Dr Johnson, described him in a letter as 'a charming creature, generally known in society as the King's Fisher'. He was known as a generous patron of authors and artists as well as being a leading churchman. His wife Dorothea, whom he married in 1787, was of a Suffolk

Plate 65.
The exterior of Salisbury Cathedral from the south-east, 1811. Pencil, 13.3 × 8.9 cms (5¼ × 3½ ins). Inscribed by the artist bottom left '1811' and on the back 'Sep 30 1811'. 825–1888 [R106]

Plate 66.
Salisbury Cathedral: exterior from the south-west, 1811.
Black and white chalks on grey paper, 19.5 × 29.9 cms (7⅝ × 11¾ ins). Inscribed by the artist on the back 'Salisbury Cathedral Sepr. 11 & 12 - 1811 - S.W. view -'. This drawing used to be dated to the early 1820s, as it is evidently the basis for the great oil painting commissioned by Bishop Fisher and exhibited at the R.A. in 1823. The artist's inscription on the back was discovered when the drawing was removed from its old mount, dating it to Constable's first visit to Salisbury in 1811. This is just one of many sketches and studies which he saved for future use.
292–1888 [R105]

family, and in 1790 Fisher was given the rectorship of Langham, very near to Constable's family home. Although the parish was in practical terms administered by the curate, whom the young Constable knew, Fisher visited Langham on occasion and it seems that Constable first met him there in the summer of 1798. It was early the following year that Constable went to London with his letter of introduction to the Academician Joseph Farington – and Farington was also an old friend of Fisher's.

In May 1802, Constable was invited by Fisher to Windsor, where he was to be introduced as a prospective drawing master at the nearby Royal Military College. During this visit, Constable arose before 7am to make drawings of Windsor Castle from the other side of the Thames, presumably to be presented as test-pieces at his interview (plate 67). The two pencil drawings in the V&A collection are delicate in touch, and very lightly washed in watercolour. He clearly made a special effort to convey the details of the architecture of the castle, but it is the effect of the early morning light that dominates. He was offered the job but, following the advice of both Farington and Benjamin West, then President of the R.A., he refused it. Nevertheless, Fisher invited him to dinner at St James's Palace later that year and, although there is very little evidence, they must have kept up their acquaintance, for it was nine years later, in 1811, that Constable was invited

Plate 67.
Windsor Castle from the river, 1802. Pencil, red chalk and watercolour, 25.9 × 36.5 cms (10¼ × 14⅜ ins). Inscribed by the artist bottom left 'May 17. 1802. 7 – morning'. 804–1888 [R33]

to stay at the Bishop's Palace in the Cathedral Close at Salisbury. His visit lasted about three weeks, from mid-September onwards. As well as drawings of the cathedral (plates 65 and 66) he also made, among other excursions, a trip to the nearby great house of Stourhead with its remarkable landscaped garden inspired by the paintings of Claude. From one of his 1811 drawings he made an oil painting which he exhibited at the R.A. the following year (possibly the *Salisbury from Harnham Hill* now in the Louvre).

Probably the most decisive episode during this 1811 Salisbury visit was Constable's meeting with the younger John Fisher, the Bishop's nephew. The Bishop's only son Edward had severe learning difficulties, and his nephew seems to have taken his place in terms of the Bishop's affection and ambition. John (1788–1832) had graduated from Cambridge University the year before; he was twenty-three years old while Constable was now thirty-five. Most of Constable's friends at this time were older than him: John Dunthorne, back in Suffolk, was only six years older, but George Frost was more than twenty years his senior, as were his other contacts in the art world such as Farington. One reason Constable's friendship with the younger Fisher prospered may have been that they both shared the new ideas of the nineteenth century,

while his older friends had inherited and cherished the artistic tastes and ideals of the mid-eighteenth century.

In 1812 the younger Fisher was ordained. The first of his many letters to Constable dates from March of that year, urging him to visit Salisbury again, which demonstrates how quickly their friendship had flourished:

As I see the [R.A. summer] Exhibition (my pen is the better for mending; is it not?) is advertised I conclude your labours are over for the present; so I put you in mind of your promise to come and visit me here at Salisbury. I shall be in town on the twentieth of May shall be ordained priest on the first Sunday in June and immediately after that return into Wiltshire. You must prepare to accompany me. You know I take no refusals. All obstacles be they of whatsoever nature they must be overcome by my impetuosity.

But although they met sporadically in London, their next important contact was when Fisher officiated at the wedding of Constable and Maria Bicknell at St Martin-in-the-Fields in October 1816. Fisher himself had married in July. The Constables' ten-week honeymoon was spent principally in Salisbury, Southampton and Osmington. In Osmington, they stayed for some six weeks with the Fishers. On his marriage Fisher had been given the parish of Osmington, near Weymouth, Dorset, by his uncle the Bishop. The principal pictorial result of this visit was the famous view of Bowleaze Cove, Weymouth Bay, which exists in three versions: the V&A oil sketch (plate 44), the larger oil now in the National Gallery, and the largest oil painting now in the Louvre which was probably exhibited at the British Institution in 1819. The subject was also engraved by David Lucas for *English Landscape Scenery*. The V&A sketch is one of the most remarkable of his open-air studies: the overall sweep of the composition and the stormy atmosphere are rendered with bold strokes and touches of the brush, sometimes very liquid and almost transparent, and sometimes dry. In places he uses a thick impasto, giving an added vitality (plate 68), especially to the figures and their dogs walking on the beach. Much of the invigorating breeziness of the sketch, which must have been painted spontaneously on the spot, is inevitably lost in the exhibited picture. It was this open-air freshness that so appealed to artists in France, such as Jean Baptiste Camille Corot (1796–1875) and Charles François Daubigny (1817–78), and discussed later in chapter 10.

Constable also made many drawings in his sketchbooks, ranging from the delicate pencil sketch of *Portland Island from Chesil Bank* (plate 69), which

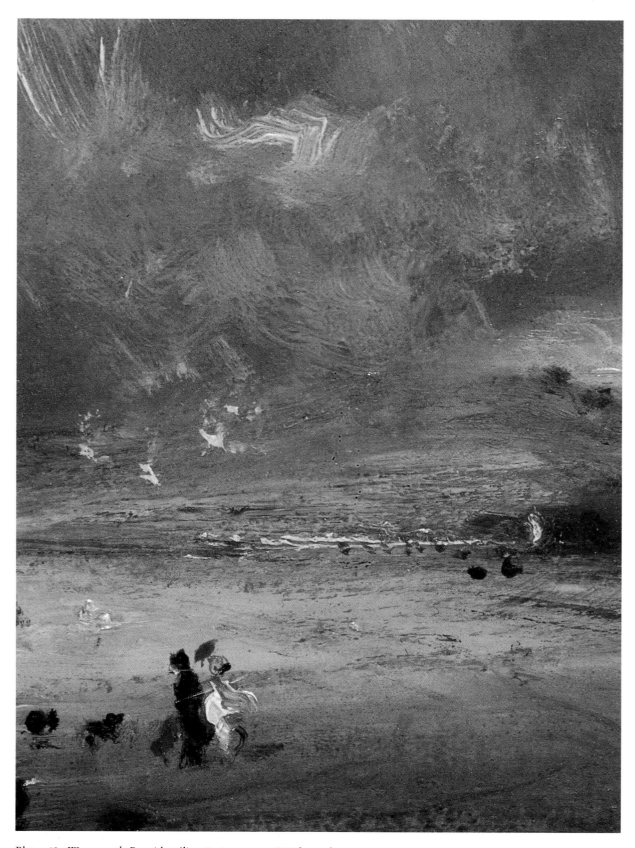

Plate 68. *Weymouth Bay* (detail), 1816. 330–1888 [R155]

Plate 69. *Portland Island from Chesil Bank*, 1816. Pencil and watercolour, 11.5 × 18.1 cms
(4½ × 7⅛ ins). Inscribed by the artist top left 'Portland Island Novr.20.1816'. This page from a
sketchbook has a rapid pencil drawing of a nearby coastal scene on the back, made during
John and Maria's honeymoon. 628–1888 [R152]

Plate 70. *Netley Abbey: the exterior seen amid trees*, 1816. Pencil, 11.5 × 18.1 cms (4½ × 7⅛ ins).
A page from a sketchbook, drawn during the artist's honeymoon. The drawing was used later
for Constable's etching of the subject, and even later as the basis for an oil sketch and a
watercolour. On the back is a quickly drawn map of the roads from Ringwood in Hampshire to
Osmington in Dorset. 268–1888 [R148]

Plate 71. *A view at Salisbury from Archdeacon Fisher's House*, *c*.1820. Oil on canvas,
20 × 25.1 cms (7⅞ × 9⅞ ins). 320–1888 [R320]

is faintly washed with watercolour, to the vigorous pencil study of the exterior of Netley Abbey (plate 70), the composition of which he later translated into an etching, an oil study, and a watercolour.

A longer visit to the Fishers was made in 1820, following their move to Leadenhall, a house in a corner of the Cathedral Close at Salisbury that came with Fisher's appointment as prebendary. By this time, the Constables had two children: John Charles born in 1817 and Maria Louisa born in 1819. In a letter of 22 June, Fisher urged that 'Mrs Fisher is delighted with the thoughts of seeing Mrs Constable & her little boy', adding in a note dated 30 June to 'bring your babe with you: we have plenty of room'. The coach journey from London to Salisbury was sixteen hours, but they all arrived on about 7 July, and were back in Hampstead by the beginning of September.

It was probably during his 1820 visit that Constable made a careful sketch of the view from Fisher's house (plate 71). The application of the pigments is thick and liquid, the fresh and bright greens enhanced by specks of pure white paint. The composition is informal, and it seems likely that Constable painted it for his own pleasure rather than with a further painting in mind. As recent writers have commented, the mood of the painting is utterly serene and contented, the horizontals of the foreground railings echoed in the brick wall behind, the long shadows of the trees, the far edge of the field, and the gently slanted distant horizon. These horizontals are only broken by the diagonal wall in the left foreground, which directs our eye into the distance. The trees, in full leaf, have simply rounded contours and are silhouetted against a tranquil (perhaps early morning) blue sky interrupted by only a few wispy clouds.

It was during this 1820 stay that Constable made his only recorded visit to Stonehenge, making a pencil drawing of the monument which was to be the basis for one of his most famous exhibited watercolours sixteen years later (plates 55, 56 and 57). He appended a text to the title of his 1836 R.A. exhibit of Stonehenge: 'The mysterious monument of Stonehenge, standing remote on a bare and boundless heath, as much unconnected with the events of past ages as it is with the uses of the present, carries you back beyond all historical records into the obscurity of a totally unknown period'. Constable's younger brother Abram wrote to him from East Bergholt on 20 May 1836 about the watercolour of Stonehenge, enquiring 'Where did you get the quotation for it?' This question has never been resolved; it seems

most likely that Constable adapted part of the text of John Britton's book on the antiquities of Wiltshire, published in 1814, of which he owned a copy.

The following year, early in June 1821, Constable toured Berkshire with Fisher. It was a busy year: he had completed *The Hay Wain* in time for the R.A. summer exhibition, and was settling into his new house in Hampstead. At the beginning of November he took the early 'Little Salisbury' coach from St Clement's at 6am, arriving in Salisbury at 8pm. On this visit he went to Winchester where, as he wrote to his wife, he found the cathedral 'more impressive but not so beautiful as Salisbury'.

In 1823, Constable exhibited *Salisbury Cathedral from the Bishop's Grounds* (plate 63) at the R.A., where it received mixed reviews, but mostly admiring. *The Literary Gazette* on 3 May thought it 'striking but mannered…Beautiful as it is, variety would be more agreeable', while in the June issue of the *London Magazine* the critic compared the painting to the work of the great seventeenth-century Dutch master Meindert Hobbema (1638–1709). This must have pleased Constable, as he much admired Hobbema. In a letter of 9 May, Constable wrote to Fisher:

My Cathedral looks very well. Indeed I got through that job uncommonly well considering how much I dreaded it. It is much approved by the Academy and moreover in Seymour Street though I was at one time fearful it would not be a favourite there owing to a dark cloud – but we got over the difficulty…It was the most difficult subject in landscape I ever had upon my easel. I have not flinched at the work, of the windows, buttresses, etc., etc., but I have as usual made my escape in the evanescence of the chiaroscuro.

The reference to Seymour Street (Bishop Fisher's London home) and to the 'dark cloud' introduces us to one of the best-known episodes in Constable's career. On 4 November 1822 the Bishop wrote to Constable that he was hoping the artist would take 'another peep or two at the view of our Cathedral from my Garden near the Canal…perhaps you retain enough of it in your memory to finish the Picture which I shall hope will be ready to grace my Drawing Room in London'. But the Bishop did not like the darkness of the passing cloud on the right: when he commissioned Constable to make a smaller repetition of the composition as a wedding present for his daughter Elizabeth, he wrote to his nephew on 16 October that he hoped the painter 'would but leave out his black clouds! Clouds are only black when it is going to rain. In fine weather the sky is blue'.

Plate 72. *View near Salisbury, showing the Cathedral*, 1820. Pencil, 11.5 × 18.5 cms (4½ × 7⅜ ins). Inscribed by the artist bottom left '4 [?] July 1820'. 824–1888 [R188]

Constable took the coach to Salisbury on 19 August 1823: in a letter to his wife Maria on the following day he reported that it had been 'not at all a disagreeable ride though it rained now and then...the difference in price between outside [travelling on the roof of the coach] and in is 14s [70 pence] which is not a trifle'. He visited the Fishers, now living at Gillingham in Dorset; he wrote to Maria on 24 August 'We are sadly off for weather. I can do nothing hardly'.

The beauty to which Constable responded in Salisbury was that of the architecture of the cathedral itself, and of its remarkable natural setting. The cathedral spire – the tallest in Britain – dominates the surrounding landscape even today (plate 72). Furthermore, his affection for the Fisher family coupled with the happy times he spent together with his own family in Salisbury were amplified by the character of the landscape surrounding the cathedral city. Its lanes, meadows and rivers must have reminded him of his beloved Suffolk.

John Fisher died in his early '40s, on 25 August 1832, which shocked Constable deeply. Writing to Leslie on 4 September he explained: 'This sudden and awful event has strongly affected me. The closest intimacy had subsisted between us for many years; we loved each other, and confided in each other entirely'.

CHAPTER 7
BRIGHTON, CONSTABLE AND THE SEA

By 1824, eight years after their marriage, John and Maria Constable had four children (there were to be three more), and it was already evident that Maria was unwell. Exactly when Constable became aware of his wife's illness is unclear, although it appears to have been the prime factor in the family's move from central London to Hampstead in 1819. The illness seems to have been tuberculosis, a widespread disease until well into the middle of the twentieth century and thought at the time to be hereditary. Maria's mother had died of the same condition, as had her two brothers and her sister. Constable wrote to John Fisher on 8 May 1824 that Maria had 'got much better after you left town but this warm weather has hurt her a good deal, and we are told we must try the sea – on Thursday I shall send them to Brighton'. Before her marriage Maria had known Brighton well, and it seems she enjoyed her visits there.

Brighton (plates 73 and 74) had been a popular health resort since about 1750, when the benefits of sea-bathing, and even the drinking of sea-water, were 'scientifically' proved. The town became especially fashionable – as Bath had been since the late seventeenth century – after the Prince of Wales, later George IV, rebuilt the Royal Pavilion. In the early 1820s Brighton was expanding as a popular tourist resort as well as a spa. Great hotels were under construction, notably the York and the Albion, and the impressive Chain Pier, which Constable referred to as 'the dandy jetty', opened in 1823.

It is likely that Constable accompanied his family, with a nurse and a maid, to Brighton on 13 May 1824 to take a house in Weston Place, at the west of the town and close to the beach. As there was a rapid coach service between London and Brighton, Constable was able to visit his wife and children several times during the summer and autumn of 1824. When they were apart, Constable in London and Maria and the children in Brighton, they kept in touch by letter. The letters deal with both exalted and banal matters: for example, one from Maria delivered to Constable on 24 May recorded that she did 'nothing but study skies all day', reminded him to 'bring the little key with you', and ended 'the children are all, very, very noisy, and out a great deal, but they have interrupted me, so I have forgot the rest I have to say'. He wrote to her on 28 May, with a typical mixture of personal and professional information, and genuine concern for the happiness of his family:

Really it is ruin to me to be out of town at this time of year [presumably due to Constable's need to meet collectors and dealers during the R.A. summer

Plate 73.
Alfred Crowquill
(pseudonym of Alfred
Henry Forrester,
1804–72), *Beauties of
Brighton*, 1825.
Pen and ink and water-
colour, 22.4 × 32.9 cms
(8¹³/₁₆ × 12¹⁵/₁₆ins).
P.6–1932

exhibition] – but I now want the sea air as much as you. My cheeks are always disagreeable hot, and pains in my shoulders and eyes and throat from cold – but the weather is now so lovely that though the wind is east it is a summer's day. I shall bring some little picture down with me to keep going on with at all the odd times I can find to come to you, which will be to stay as the season advances. I hope you are reconciled to the house [this implies that Maria did not like it at first sight]. If not, we will have one that will do at any price. I must and will have you and my chicks comfortable...Your ear ring has come home. Do you want it. I cannot find Stodhart's book...Ann Gubbins called and was vexed to find me out.'

Constable's feelings for Brighton were mixed. His most often quoted comments are recorded in a long letter posted from there on 29 August 1824 to John Fisher:

I am living here but I dislike the place...Brighton is the receptacle of the fashion and offscouring of London. The magnificence of the sea, and its (to use your own beautiful expression) everlasting voice, is drowned in the din and lost in the tumult of stage coaches, – gigs – flys etc. – and the beach is only Piccadilly... by the sea-side – ladies dressed and <u>undressed</u> – Gentlemen in morning gowns and slippers on or without them altogether about knee deep in the breakers – footmen – children – nursery maids. dogs. boys. fishermen – preventive service

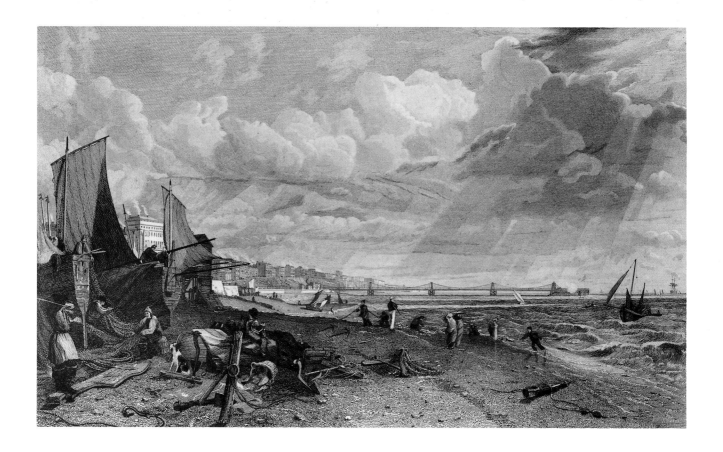

men (with hangers and pistols). rotten fish and those hideous amphibious animals the old bathing women, whose language both in oaths and voice resembles men – all are mixed up together in endless and indecent confusion – the genteeler part the marine parade is still more unnatural – with its trimmed and neat appearance and the dandy jetty or chain pier – with its long and elegant strides into the sea a full quarter of a mile...

He ended this long diatribe by saying, 'in short there is nothing here for a painter but the breakers – and sky – which have been lovely indeed and always varying'.

The sea and the sky of course appealed to Constable's sensitivity to the effects of constantly changing light and atmosphere. He turned his back on the houses and hotels of 'Piccadilly-by-the-seaside', and painted everyday life on the beach, just as he had done in the valleys of the River Stour and on the heights of Hampstead Heath. He was not interested in the bathers and their attendants or the fashionable visitors, apart from being targets for his derision, but he painted the fishermen, sailmakers, net repairers and boats, both at sea or being serviced on the beach. A rare exception is a sketch looking directly out to sea, which his daughter Isabel gave to the R.A. and

Plate 74.
Frederick Smith after Constable, *View of Brighton, with the Chain Pier*, 1829. Engraving, 28 × 38.1 cms (11 × 15 ins). Published by Colnaghi, 1829.
1252–1888

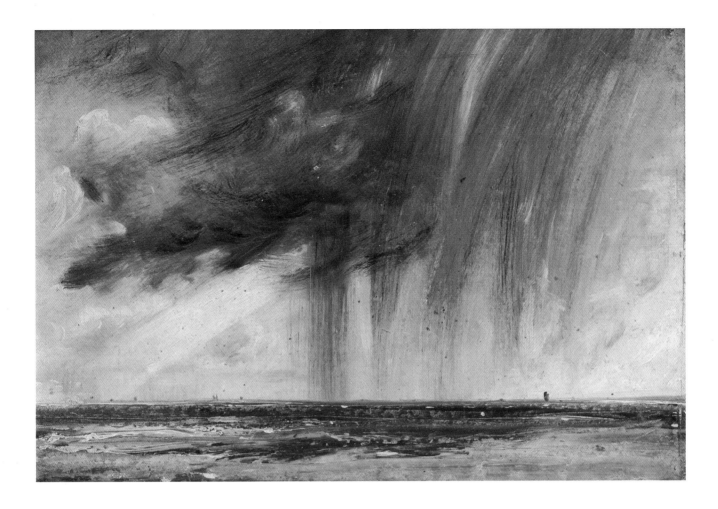

Plate 75.
Rainstorm over the sea,
*c.*1824–8. Oil on paper laid
on canvas, 22.2 × 31 cms
(8¾ × 12¼ ins). A very rare
work, painted as Constable
looks out to the sea, and
with no workmen present in
the foreground.
Royal Academy of Arts

which is one of his most Turneresque paintings (plate 75). The earliest oil
sketch made in Brighton is of a fishing boat and its crew seemingly being
unloaded on the shore; it is inscribed on the back with the date 10 June 1824
(plate 76). On a later visit, his third and longest stay that year, Constable
painted one of his most famous oil sketches, *Brighton Beach, with colliers*
(plate 77). Characteristically, as with many of his Hampstead sketches, he
annotated the sketch on the back: '3rd tide receding left the beach wet – Head
of the Chain Pier Beach Brighton July 19 Evg., 1824 My dear Maria's
Birthday Your Goddaughter – Very lovely Evening – looking Eastward –
cliffs & light off a dark [?grey] effect – background – very white and golden
light'.

The reference in the inscription to 'Your Goddaughter' indicates that
Maria's godfather, John Fisher, was to be the recipient of the sketch. Indeed
Constable sent a batch of oil sketches to Fisher on 5 January 1825, with a
covering letter:

I am just returned from conveying to the coach office in Oxford St. a box for
your and Mrs. J. Fisher's amusement...I have enclosed in the box a dozen of my
Brighton oil sketches – perhaps the sight of the sea may cheer Mrs F – they were

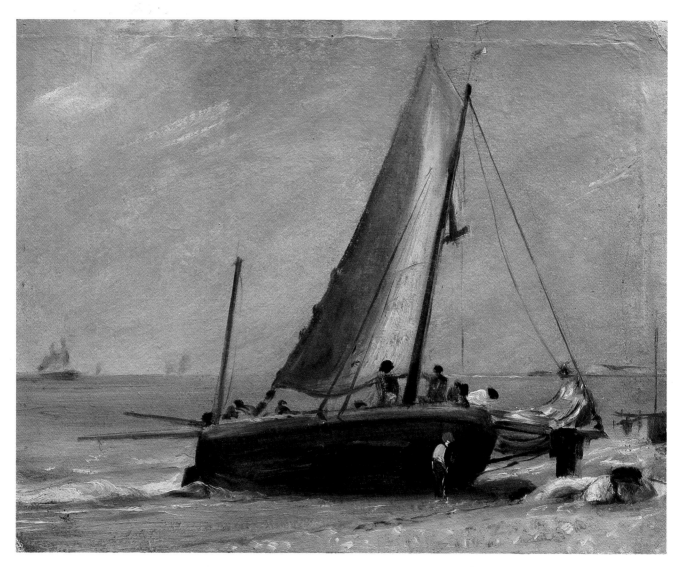

Plate 76. *Brighton Beach, with fishing boat and crew*, 1824. Oil on paper,
24.4 × 29.8 cms (9⅝ × 11¾ ins). Inscribed in pencil on the back 'Brighton June 10 1824'.
This seems to be the earliest of Constable's oil sketches of a Brighton scene.
782–1888 [R263]

Plate 77. (*opposite, top*) *Brighton Beach, with colliers*, 1824. Oil on paper,
14.9 × 24.8 cms (5⅞ × 9¾ ins). Inscribed by the artist in pencil and pen and ink on the
back. As well as fishing boats, Brighton beach was also a landing place for deliveries of
coal, an important commodity for such a populous town. The coal trade interested
Constable as it was part of the family business in Suffolk. The end of the Chain Pier is
visible behind the boats. 591–1888 [R266]

done in the lid of my box on my knees as usual. Will you be so good as to take care of them. I put them in a book on purpose – as I find dirt destroys them a good deal. Will you repack the box as you find it. Return them to me here at your leisure but the sooner the better.

Although we associate Constable with the depiction of lushly verdant landscape, with trees and grasses, corn and wheatfields, plants and weeds, he very often included the element of water in his paintings. This should not be surprising to any who know 'Constable country' in Suffolk. It was the river that formed the highway in the Stour valley. Water served a day-to-day practical role in transportation, which was part of Constable's father's business. For Constable, as surely for countless others, the water of rivers, lakes and seas aroused an aesthetic response both visual and aural. As Constable appreciated, hearing the natural world may be as rewarding as seeing it. Water reflects light from the sky (not only in bright sunshine) from its surface to its surroundings: you can see this in the oil paintings of Hampstead Heath, the

Watermeadows at Salisbury and the two large sketches for *The Hay Wain* and *The Leaping Horse*. As for the dimension of sound, Constable famously told his friend and biographer Leslie that it was not only 'willows, old rotten planks, slimy posts, and brickwork' that had made him want to be a painter, but also 'the sound of water escaping from mill-dams'. The sounds of water – the breeze rippling the surface of the River Stour in Dedham, or the waves crashing on the beach at Brighton – excited Constable's imagination, and he translated his experience into pictorial form.

As well as beach scenes, there were the views painted on the downs above Brighton, where the skyscapes were similar to those in Hampstead. He found the terrain desolate and neglected in comparison with the greatly cultivated agricultural landscape of the Stour valley, writing on the back of one sketch: 'Brighton Augst.3d 1824 Smock or Tower Mill west end of Brighton the neighbourhood of Brighton – consists of London cow fields – and hideous masses of unfledged earth called the country'. He often used a windmill, another reminder for him of the Suffolk countryside, as a dominant focus in an otherwise almost featureless landscape (plate 78).

Plate 78.
A windmill near Brighton, 1824. Oil on paper, 16.2 × 30.8 cms (6⅜ × 12⅛ ins). Inscribed in pencil on the back by the artist 'Brighton Augst. 3d 1824 Smock or Tower Mill west end of Brighton…' (see adjacent text). Although attracted to the downs above the town of Brighton, Constable considered the landscape featureless and uncultivated compared with that of his beloved Suffolk.
149–1888 [R268]

Plate 79.
Hove Beach, with fishing boats, 1824. Oil on paper laid on canvas, 29.8 × 49.2 cms (11¾ × 19⅜ ins). The view looks towards Worthing on the left, with Highdown Hill in the centre and Cissbury on the right. 129–1888 [R270]

He also made a number of excursions along the coast, for example to near-by Hove (plate 79). Then, as now, a less populated town than Brighton without the bustle of fishermen and tourists, Hove gave Constable the same opportunity to concentrate on the sea, sky and beach that Weymouth Bay had afforded him eight years before. As with the famous *Weymouth Bay* of 1816 (plates 44 and 68), he introduces a very few figures strolling on the beach. These provide a contrast to the dramatic crashing of the waves and movement of the clouds, and add a human presence to the elements of nature.

The principal and most impressive result of his work in Brighton was the great *Chain Pier*, painted in 1826–7 and exhibited at the R.A. in 1827; it is now in the Tate Gallery (plate 80). Studies of fishing tackle used in the painting (plate 81) and the original panoramic pencil drawing for the composition (plate 82) are both in the V&A collection. The studies of fishing tackle are very precise, much in the manner of his drawings and oil

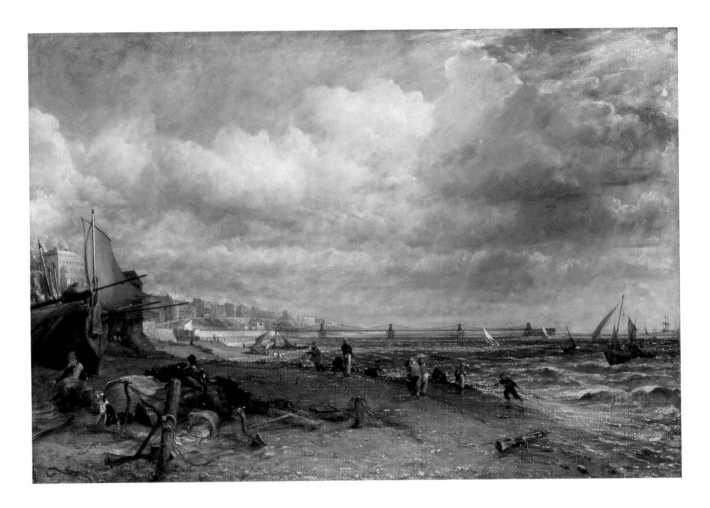

Plate 80. *The Chain Pier, Brighton, 1826–7.* Exhibited at the R.A. 1827 and British
Institution 1828. Oil on canvas, 127 × 183 cms (50 × 70 ins). This Brighton subject can
be added to the series of 'six-footers' painted in Suffolk. The composition, with the
weight of the boat and building (the new Albion Hotel) balanced by the heavy clouds
on the right, is similar in structure to several of Constable's larger paintings, including
The Opening of Waterloo Bridge and *Hadleigh Castle.*
Tate Gallery 5957

Plate 81. (*opposite, top*) *Studies of fishing gear on the beach at Brighton, 1824.*
Pen, pencil, and grey and pink wash on a page from a sketchbook, 18.1 × 26.4 cms
(7⅛ × 10⅜ ins). These are studies used for the oil painting of *The Chain Pier* (plate 80).
On the back of the sheet are four other sketches of various figures and boats, also made
in Brighton. 605–1888 [R273]

sketches of such farm equipment as ploughs and carts, water wheels and locks, and the construction and rigging of boats and ships. The composition of the panoramic pencil study, a remarkable work of art in its own right, was much altered in the finished painting; the viewpoint is more distant in the oil painting, with the hotels, houses and Chain Pier itself taking a subsidiary role to the foreground beach and its workers, their boats, implements and apparatus.

The atmosphere of *The Chain Pier* is stormy, and it is sometimes suggested that this reflected Constable's anxiety at the time about his wife's fatal illness. This is of course understandable, although there are paintings by him of the later 1820s which are bright and happy in appearance. But Constable's anxiety of mind and its possible pictorial expression was noticed at the time:

Fisher wrote to him, on 7 December 1828, to say that: 'I wish if "Brighton" is not out of your possession that you would put it on an easel by your side...and so mellow its ferocious beauties. Calm your own mind and your sea at the same time, and let in sunshine and serenity'.

It may have been due to its grim vigour that *The Chain Pier* did not find a buyer, either at the R.A. in 1827 or at the British Institution the following year; it finally sold at the artist's posthumous studio sale in 1838. The newspaper and magazine reviews were mixed in tone. On 8 May 1827 the *Sun* thought the picture was 'marked by this artist's usual strict adherence to nature' and 'the atmosphere possesses a characteristic humidity about it, that almost imparts a wish for an umbrella'. *The Times* critic on 11 May 1827 thought it 'one of his best works' and went on to comment on Constable's unpopularity with collectors: 'He is unquestionably the first landscape painter of the day, and yet we are told his pictures do not sell'. The critic continued 'He accounts for this by stating that he prefers studying nature as she

Plate 82.
The Marine Parade and Chain Pier, Brighton, c.1826–7. Pencil, with pen additions, 11.1 × 42.1 cms (4⅜ × 16¾ ins). A study for the large oil painting (plate 80).
289–1888 [R289]

presents herself to his eyes rather than as she is represented in old pictures, which latter is, it seems, the "fashionable" taste. That such a word should be heard of in matters of art!'

Constable's last 1824 trip to Brighton was in October; he took his family there again in the following autumn, again in 1826, and in the spring of 1828, but Maria died in Hampstead on 28 November of that year. Constable had written to John Carpenter on 23 July that he had been 'attending a very sick wife and afflicted child [Alfred, the youngest]...Brighton has done them very little good'. After his wife's death, apart from a very short visit in 1830, Constable effectively severed his connection with Brighton.

CHAPTER 8
CONSTABLE AND HAMPSTEAD

Like most professional artists of his time, Constable needed a home in London, particularly during the weeks following the opening of the annual R.A. summer exhibition. It was then that he met and negotiated with prospective buyers of his paintings. The year after his marriage to Maria, in 1816, he took a house in Keppel Street, Bloomsbury. Five years later he bought Joseph Farington's house, 35 Charlotte Street, in nearby Fitzrovia.

Constable did not enjoy living in central London, and perhaps his wife's increasing ill-health may not have been the only reason for the family moving out to the north-west of the city. For the summer of 1819 they rented Albion Cottage, Upper Heath, Hampstead, and his earliest known dated oil painting of Hampstead is from that summer: *Branch Hill Pond* (plate 83). It must have been a happy year, as in November he was at last elected Associate of the R.A. The view of Branch Hill Pond, looking west from near Judges Walk, was to be one of his most favourite subjects. He

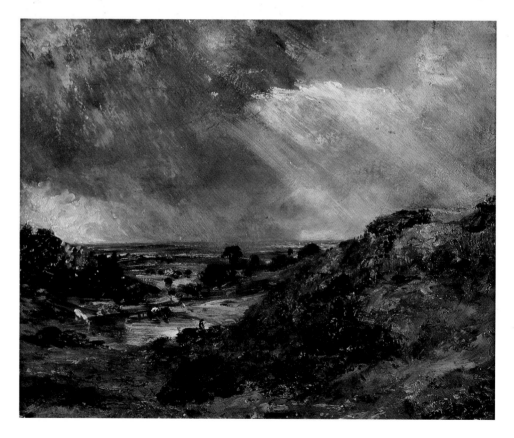

Plate 83.
Branch Hill Pond, Hampstead, 1819. Oil on canvas, 25.4 × 30 cms (10 × 11⅞ ins). Constable's earliest known dated oil painting of Hampstead, where he first rented Albion Cottage for the summer of 1819. The view, which became one of his favourite subjects, is from near Judges Walk looking west over Branch Hill Pond. 122–1888 (R171)

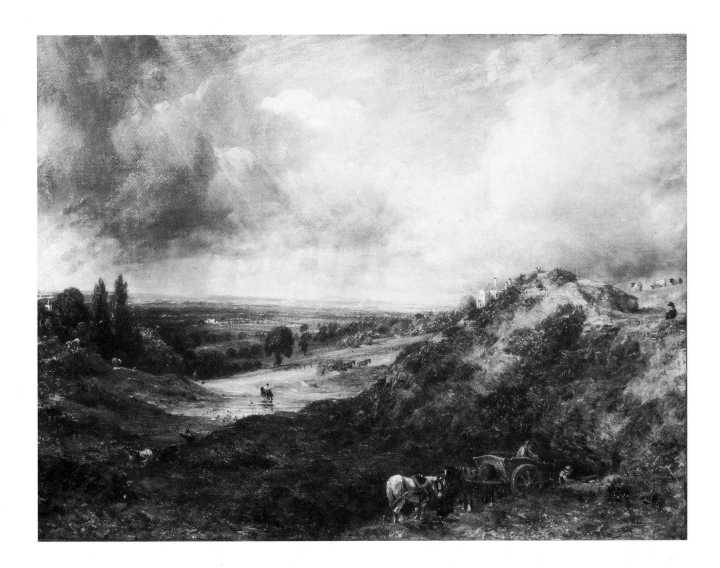

Plate 84.
*Hampstead Heath:
Branch Hill Pond*, 1828.
Exhibited at the R.A. 1828.
as *Landscape*. Oil on
canvas, 59.6 × 77.6 cms
(23½ × 30½ ins).
FA 35 (R301)

developed the composition into a more finished painting, exhibited at the
R.A. in 1828 with the simple title *Landscape* (plate 84).

The subsequent history of *Landscape* gives an insight into the problems
that still existed at this time between artist and buyer. Constable thought that
Sir Francis Chantrey, the eminent sculptor and art collector, had purchased
the painting from the 1828 R.A. exhibition. But it seems the painting 'some-
how got intangled with Chantrey in a most ridiculous way – who will neither
take it nor refuse it', as Constable wrote to Leslie as late as 4 March 1832,
after another collector, Francis Lawley, saw it in the artist's studio and
expressed an interest in buying it. Constable continued his letter: 'I want
much your never failing advice on this (to me) momentous subject – for I
don't catch above one fish in seven years. Mr Lawley will call again to know
his and the picture's fate.' It seems most likely that Constable eventually sold
the painting soon afterwards, directly to John Sheepshanks, for £84.

Because both of Constable's R.A. exhibits in 1828 were titled simply

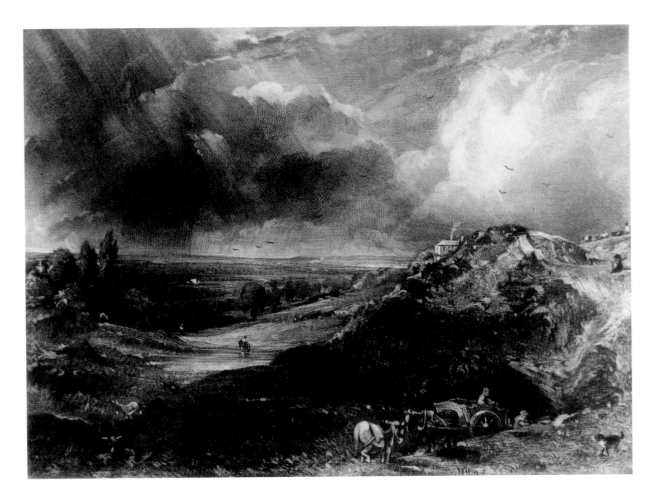

Landscape, one the V&A *Branch Hill Pond*, the other the large *Dedham Vale* now in the National Gallery of Scotland (plate 41), it is impossible to determine to which painting contemporary critics were referring in their reviews. The critic for the *Sun* on 5 May, for instance, could be describing either picture here: 'A rich and varied piece of colouring, imbued all over with the qualities of English landscape. A shower has apparently just passed over, and a few flitting clouds throw their flickering light and shades over the country. The gleaming water in the distance is inimitable'.

Constable painted several versions of this favourite subject: there are oil paintings of Branch Hill Pond in the Tate Gallery, including the last version of 1835, with others in the Cleveland Museum of Art, Ohio; the Museum of Fine Arts in Richmond, Virginia; the Philadelphia Museum of Art; and the

Plate 85.
David Lucas (1802–81) after Constable, *A Heath* (Hampstead Heath: Branch Hill Pond), published 1831. Mezzotint, approximately 29.4 × 43 cms (11⅝ × 17⅛ ins). This was first issued in 1831 in Part 3 of *English Landscape Scenery*, the book of engravings of Constable's work.
E.2410–1901
(in volume 95.G.3)

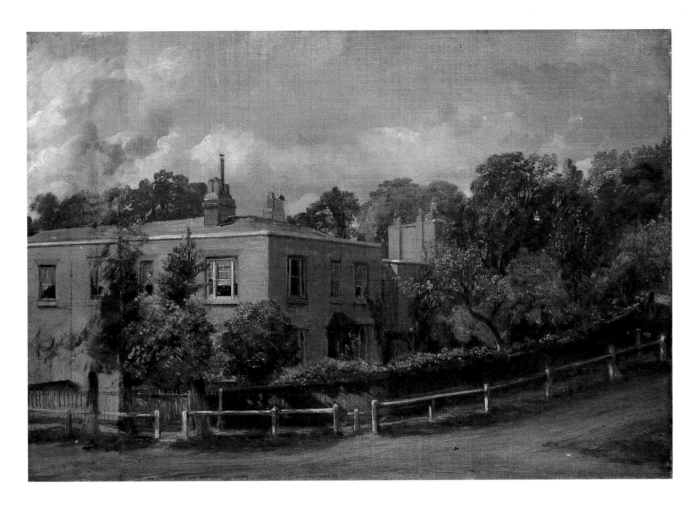

Plate 86.
View of Lower Terrace,
*Hampstead, c.*1822.
Oil on canvas,
24.8 × 35.2 cms
(9¾ × 13⅞ ins).
584–1888 (R252)

Oskar Reinhart Foundation at Winterthur, Switzerland. David Lucas engraved the subject in mezzotint for one of the most beautiful plates in *English Landscape Scenery* (see chapter 9), where it was simply entitled *A Heath* (plate 85).

In 1821 and 1822 Constable rented a house at 2 Lower Terrace, Hampstead, where he converted a hut in the garden into a studio. He wrote to Fisher on 4 August 1821: 'I have cleared a small shed in the garden, which held sand, coal, mops and brooms, and that is literally a coal hole, and have made it a workshop, and a place of refuge...I have done a good deal of work here'. There are two oil sketches in the V&A, one a view of the next-door houses in Lower Terrace (plate 86) and another which seems to show his garden and the shed-studio (plate 87).

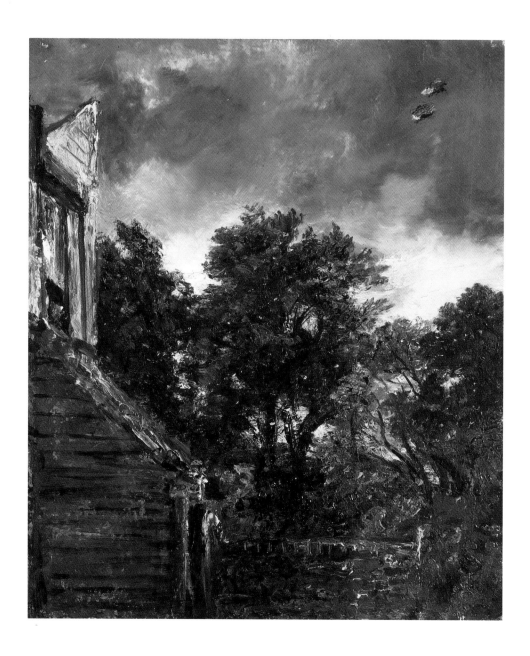

Plate 87. *View in a garden, with a shed on the left, c.*1821. Oil on paper laid on canvas, 30.2 × 23.8 cms (11⅞ × 9⅜ ins). 133–1888 (R231)

The Constable family rented various houses in Hampstead every summer, even in 1824 when they were based principally in Brighton, until they moved there permanently in August 1827, leasing No 6 (now No 40) Well Walk. Perhaps another reason for Constable moving his family from Charlotte Street was that he had discovered the house opposite was a brothel; he had taken its owner to court in 1822. The rent for Well Walk was £52 a year, plus £25 taxes, about £10 for repairs and £24 for the lease. (Constable rented out part of the house in Charlotte Street, keeping two rooms and a studio for himself.) They acquired a cat, naming it 'Mrs Hampstead'. Constable described the house to Fisher in a letter of 26 August 1827:

I am at length fixed in our comfortable little house...and we are once more enjoying our own furniture and sleeping on our own beds. My plans in the search of health for my family have been ruinous – but I hope now that my movable camp no longer exists – and that I am settled for life...It is indeed everything we could wish. It is to my wife's heart content – it is situated on the eminence at the back of the spot in which you saw us – and our little drawing room commands a view unequalled in Europe – from Westminster Abbey to Gravesend.

From the house in Well Walk Constable could see Hampstead Heath, which was only a few minute's walk away, but could easily reach the house in Charlotte Street. As he wrote to Fisher on 28 November 1826, he was 'three miles from door to door – can have a message in an hour – and I can always get away from idle callers – and above all see nature – and unite a town and country life'. He was not always so enthusiastic about the new Hampstead home, partly because of the additional cost of keeping on part of the house in Charlotte Street. He had written to Fisher in July 1825 complaining that 'Hampstead is a wretched place, so expensive – and as it was so near I made my home at neither place. I was between two chairs – and could do nothing.' But this latter comment does not seem to be indicative of Constable's real feelings for Hampstead.

High above London to the north-west, Hampstead was famous for its fresh air, away from the smoke and noise of the City and West End, and for its open panoramic views across the Heath (plate 88). 'So fresh, so bright, so sunshiny', Constable wrote to his friend George Constable in March 1836. Several writers and artists had made their homes there – the poet John Keats in Well Walk in 1817, the painters William Collins (1788–1847) and John Linnell (1792–1882) in North End in the 1820s, for example – and the

district today still retains something of its earlier village-like quality and its (if respectable) bohemianism.

Constable of course was particularly attracted to the magnificent skyscapes in Hampstead, of which he made many studies in both oil and watercolour. He believed that in a painting the sky was 'the key note, the standard of scale, and the chief organ of sentiment', and he not only made sketches and studies of cloud formations but also read books on what were comparatively new areas of scientific research, climatology and meteorology. He must have read Luke Howard's pioneering work *The Climate of London*, published in parts between 1818 and 1820, the first chapter of which was devoted to a study of clouds. He must also have been aware that, more than a 100 years before, the marine painter William van de Velde the younger (whose work Constable much admired) had climbed to the top of Hampstead Heath to make cloud studies. Constable, uniquely, annotated the back of many of his drawings with details of the exact time of day, the prevailing weather conditions, and the direction of the wind (plate 89). Sometimes his paintings show a narrow horizontal band of the tops of trees above which the clouds roll by, but more often his landscapes are dominated, physically ('the standard of scale') and emotionally ('the chief organ of sentiment') by the sky. A senior member of the Royal Meteorological Society wrote in 1937 that Constable's cloud

Plate 88.
George Sidney Shepherd (working 1821–61), *View on Hampstead Heath*, 1833. Probably exhibited at the R.A. 1834.
Watercolour, 30.2 × 47 cms (11⅞ × 18½ ins). Inscribed by the artist bottom right 'Geo.Sidney Shepherd.1833. Finished on the spot'.
The road ahead leading into the distance is Downshire Hill, with Well Walk parallel on the right. As a topographical view looking away from the heath towards Hampstead village, this watercolour gives a very specific image of the place during Constable's residence.
51–1896

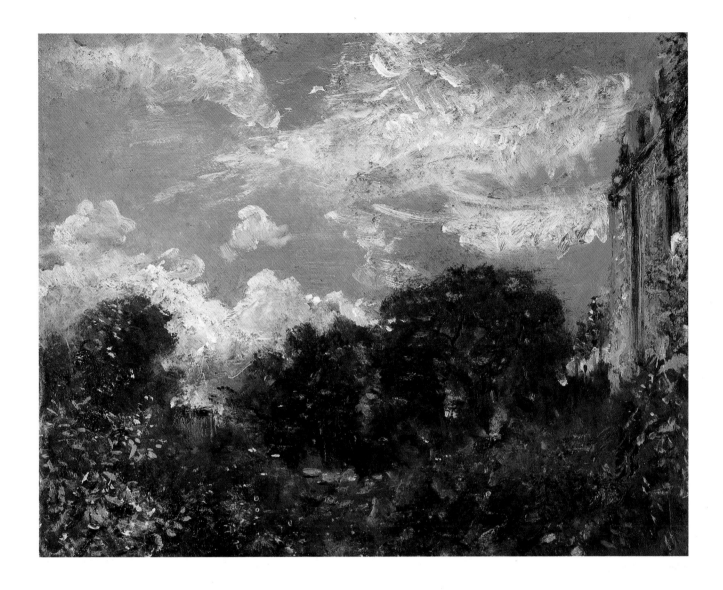

Plate 89.
*Study of sky and trees,
with a red house, at
Hampstead*, 1821. Oil on
paper, 24.1 × 29.8 cms
(9½ × 11¾ ins).
Inscribed on the back
'Sepr.12.1821.Noon.
Wind fresh at West Sun
very Hot. looking
southward exceedingly
bright vivid & Glowing,
very heavy showers in the
Afternoon but a fine
evening. High wind in
the night'.
156–1888 (R222)

studies were 'highly realistic, thoroughly true to type, and full of dynamic force…[his] clouds also excel in their dynamic quality and suggestiveness of change'.

There were also the panoramic views. On a clear day today, from the grounds of Kenwood House adjacent to Hampstead Heath, for example, you can see across the dome of St Paul's and the tower blocks of the City to Greenwich in the south-east and past the Post Office Tower to Crystal Palace in the south-west. Constable recorded such vistas; one watercolour of 1833 shows the silhouette of St Paul's Cathedral dominating the horizon (plate 90). The version of *Branch Hill Pond* now in the Virginia Museum of Fine Arts was exhibited at the R.A. in 1825, alongside a companion picture of the same size depicting an even more extensive vista from further west on the Heath: *Child's Hill, Harrow in the Distance*. This picture is now in a private collection but an oil sketch for this in the V&A (plate 91) has the same

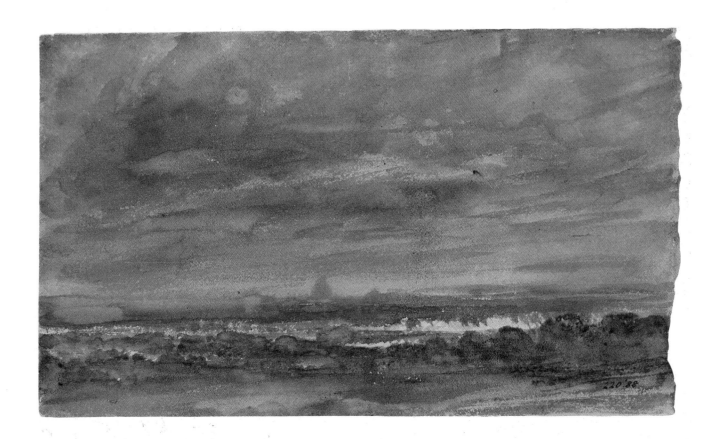

landscape and skyscape composition although it differs in the foreground details.

Constable wrote to Fisher on 20 November 1821 that he wished it could be said of him as Fuseli had said of Rembrandt: 'he followed nature in her calmest abodes and could pluck a flower on every hedge – yet he was born to cast a steadfast eye on the bolder phenomena of nature'. Constable continued: 'We have had noble clouds and effects of light and dark and colour – as is always the case in such seasons as the present'. It was the rough and working terrain of the Heath, too, that aroused a vivid response in Constable. Despite his devotion to the Suffolk countryside of his boyhood and youth, he was attracted almost immediately to Hampstead Heath, particularly, as on the banks of the River Stour, when work was in progress – earth-moving, sand-digging, cattle-driving, cart-hauling.

In 1833, Constable was invited to give a series of lectures at the Hampstead

Plate 90.
View at Hampstead, looking towards London, 1833. Watercolour, 11.5 × 19 cms (4½ × 7½ ins). Inscribed on the back 'Hampd December 7, 1833 3 oclock – very stormy afternoon – & High Wind'.
220–1888 (R358)

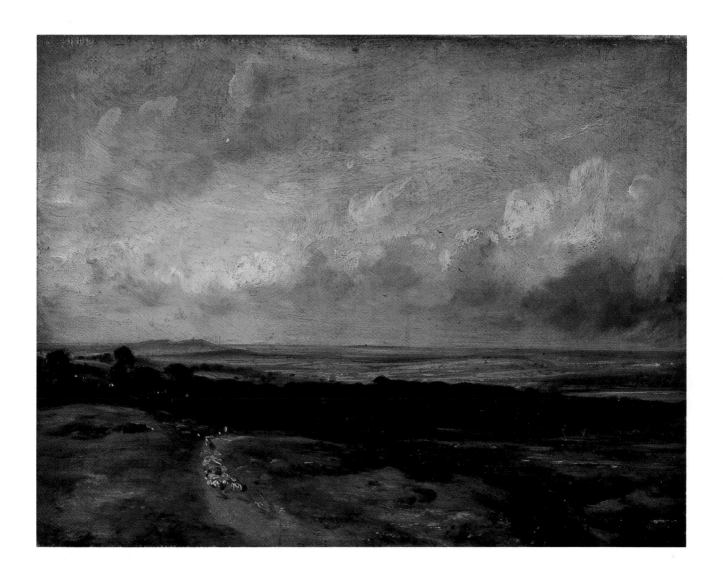

Plate 91. *Hampstead Heath, Harrow in the distance*, c.1820–25. Oil on canvas, 19.7 × 25.1 cms (7¾ × 9⅞ ins). 123–1888 (R333)

Literary and Scientific Society, which met in the rebuilt former home of the painter George Romney. The series was entitled 'An Outline of the History of Landscape Painting', and he later gave the lectures at the Athenaeum in Worcester and the Royal Institution in London, both renowned learned societies for scholars and antiquarians. In those days before photographic slides, he used his own drawings as teaching aids, including it seems the two large pencil studies of fir trees and of an ash tree made at Hampstead (plates 92 and 93). Just as the River Stour and the fields of Suffolk had 'made him a painter', so the trees on Hampstead Heath seem to have re-invigorated him and his painting. On the magnificent drawing of fir trees – which must have been made by Constable lying on the grass, looking up with his sketchbook

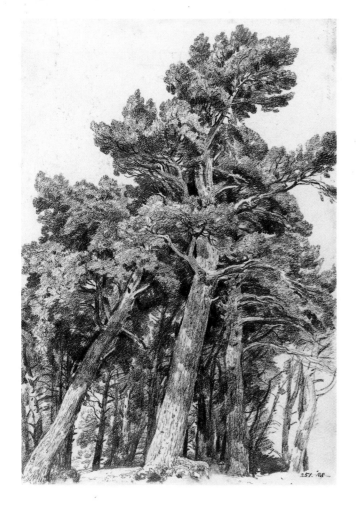

Plate 92.
Fir trees at Hampstead, 1820. Pencil, 23.3 × 16 cms (9⅛ × 6¼ ins). Inscribed vertically in the top right corner 'Wedding day. Hampstead Octr.2.1820'. Possibly a page from a sketchbook used in 1820 and 1821. Constable, marrying in 1816, is referring to his wedding anniversary. 251–1888 [R203]

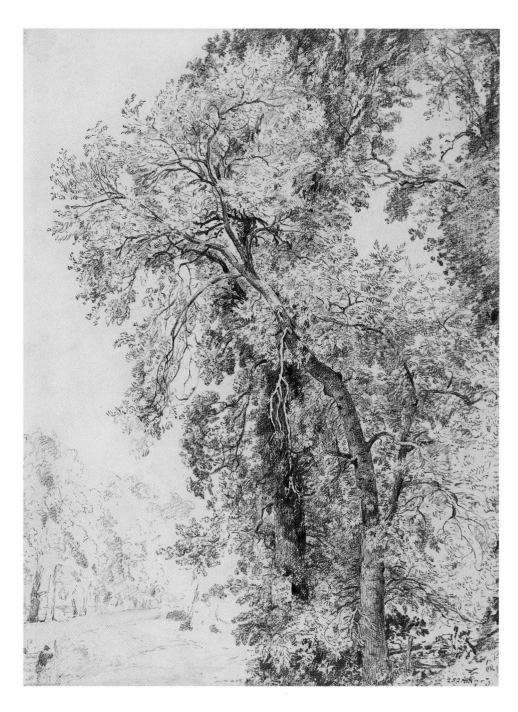

Plate 93. *Study of ash trees, c.*1821. Pencil, 32.8 × 23.8 cms (13 × 9⅜ ins). 252–1888 [R163]

on his lap – he recorded that it was his fourth wedding anniversary. This is likely to have been the drawing that William Blake once saw and remarked 'this is not drawing, but inspiration!', to which Constable is supposed to have responded 'I never knew it before; I meant it for drawing'. Constable wrote to John Fisher from Hampstead on 20 September 1821 that he had made studies 'carried further than I have yet done any...a natural (but highly elegant) group of trees, ashes, elms and oak etc.' His biographer Leslie wrote about Constable's love of trees, most memorably in the passage: 'I have seen him admire a fine tree with an ecstasy of delight like that with which he would catch up a beautiful child in his arms. The ash was his favourite...'

John and Maria's seventh and last child, Lionel Bicknell Constable, was born at Well Walk in 1828. Maria's health was rapidly declining; Constable wrote to Fisher on 11 June 1828: 'My wife is sadly ill in Brighton – so is my dear dear Alfred [their sixth child, born 1826]...Hampstead, sweet Hampstead that cost me so much, is deserted'. On 28 November 1828, Maria died at Well Walk at the age of forty-one, and was buried in Hampstead parish church. Despite what must have been unhappy associations, Constable kept the Hampstead house. Eight years later he was to write to his friend George Constable, on 16 September 1836: 'I have lately turned out one of my best bits of [Hampstead] Heath, so fresh, so bright, dewy and sunshiny...'

In his last letter to George Constable, dated 12 December 1836, the artist refers to Thomas Forster's book *Researches about Atmospheric Phenomena*, which was first published in 1812. He was using the book to prepare a series of lectures to be given in Hampstead:

My observations on clouds and skies are on scraps and bits of paper, and I have never yet put them together so as to form a lecture, which I shall do, and probably deliver at Hampstead next summer...If you want any more about atmosphere, and I can help you, write to me. Forster's is the best book – he is far from right, still he has the merit of breaking much ground.

The lectures were not to be. John Constable died during the night of 31 March 1837 at the house in Charlotte Street, but his body was taken to Hampstead to be laid beside that of his beloved Maria.

CHAPTER 9

DAVID LUCAS, THE MEZZOTINT AND
ENGLISH LANDSCAPE SCENERY

Among the twenty-two signatories of the 1768 proposal to George III for the establishment of a Royal Academy of Arts was Francesco Bartolozzi. Born in Florence in 1727, the son of a silversmith, he studied at the Florence Academy for three years before serving an apprenticeship in Venice with the engraver and printseller Joseph Wagner. In 1764, at the invitation of Richard Dalton, the King's Librarian, Bartolozzi moved to London to be the official Engraver to the King: his first project in London was a set of engravings after drawings by the Italian painter Guercino (1591–1666) in the Royal Collection. He enjoyed a long, prolific and highly successful career. The status of engraving in the art world was then comparatively lowly; it was considered more a craft than an art, seen primarily as a means of reproduction. Of the first student entrants to the R.A. Schools in 1769, only one, James Newton, gave his profession as engraver. Among Constable's contemporaries admitted to the Schools in 1800, there was only one prospective engraver, Richard Reeve.

It was Bartolozzi's early training as a painter, at the prestigious Florence Academy, that ensured his entry to the elite membership of the new Royal Academy in London. This enraged his contemporary, the professional engraver Sir Robert Strange, who went as far as to write and publish a diatribe in 1775 against the establishment of the R.A. It provoked no response, and Strange's only (posthumous) revenge is the fact that his entry in the *Dictionary of National Biography* is twice as long as that of Bartolozzi. But Bartolozzi was not only personally successful, he was an inspiration to more than one generation of engravers. For example, Samuel Reynolds studied painting at the R.A. and became a highly prolific engraver in mezzotint, and his son Samuel Reynolds the younger taught David Lucas.

Mezzotint had been invented as a medium in England in the seventeenth century, but became most popular in the second half of the eighteenth century. An engraving technique that allowed the subtle tones from black to white to reproduce more vividly the image of an oil painting, it was the most dramatic form of print-making in terms of lights and darks. This would have greatly appealed to Constable, with his devotion to 'chiaroscuro' in nature. The whole surface of the steel plate was roughened in an intricate grid of small raised dots; when ink was applied and paper pressed against the plate, the result would be a solid dense black. The black surface could then be treated with a scraper to give the grey half-tones or wiped clean with a

burnisher to give the white highlights. In effect, a print in mezzotint is not so much a reproduction as a translation of an oil painting into a different and perhaps purer language.

Leslie recorded an exchange of letters between Constable and John Fisher in 1824, concerning a trip made by Samuel Reynolds to Paris, with two assistants, to make engravings of a number of Constable's paintings that had been deposited for sale with the dealer Arrowsmith. Fisher wrote that:

I am pleased to find they are engraving your pictures, because it will tend to spread your fame: but I am almost timid about the result. There is, in your pictures, too much evanescent effect, and general tone, to be expressed by black and white. Your charm is colour, and the cool tint of English daylight. The burr of mezzotint will never touch that.

Constable's plan to translate a selection of his oil paintings into mezzotint, in a series of prints with the title *English Landscape Scenery*, probably sprang from two separate ambitions. One was his (only) attempt to bring his work to a far wider audience than those able to visit the R.A. summer exhibition or his studio. The other aim must have been to follow in the footsteps of a similar project by Claude, in the seventeenth century, which was then emulated by Turner in the nineteenth century.

From about 1635, Claude had produced a series of pen and sepia ink drawings intended to record his authentic paintings before they left his studio. There were 195 in all, plus a few others which do not seem to be related to any of his paintings. Claude titled the work *Liber Veritatis* (Latin for 'Book of Truth'). It was eventually purchased between 1720 and 1728 by the second Duke of Devonshire, and is now in the British Museum. In 1777, Richard Earlom, a leading London engraver, published his own masterpiece, a magnificent two-volume set of reproductions in etching and mezzotint after Claude's drawings in the *Liber Veritatis*. The publication was immensely successful, and the engraved plates were reworked several times for subsequent printed editions. The images inspired generations of painters, both professional and amateur, as well as landscape gardeners who attempted to reproduce Claude's compositions with real trees, shrubs, lakes and classical buildings.

Turner was evidently very impressed and influenced by Earlom's series of engravings, because shortly before 1807 he devised his own scheme to publish engraved prints after his paintings. He employed Charles Turner

Plate 94.
Joseph Mallord William
Turner R.A. (1775–1837),
*Frontispiece to the Liber
Studiorum*, 1812. Etching
and mezzotint (second state)
printed in brown ink,
18.6 × 26.3 cms
(7¼ × 10⅛ ins). Although
intended as the frontispiece,
this print was not issued to
subscribers of the series until
1812, when it was given free
with Part 10. Turner himself
did all the etched work,
although he only engraved
the centre part in mezzotint.
I.C. Easling mezzotinted the
rest of the plate.
E.2718–1927

(who had already translated Turner's 1805 oil *The Shipwreck* into a
mezzotint) to produce a hundred or more prints, to be published in twenty
periodical parts. Charles Turner completed the first four parts but other
engravers then shared the project, and the painter himself made a consider-
able contribution. Unlike Claude, Turner was not so much interested in an
authentic record of his oil paintings as in promoting his work in the several
and various categories of landscape art available to the public and to his
contemporaries. Turner's chosen title imitated that of Claude – the *Liber
Veritatis* became the *Liber Studiorum* ('Book of Studies'). The first part of
Turner's *Liber* appeared in 1807. Turner had been elected a full Royal
Academician and was considered one of the leading painters of the day.
But the project was not a popular success, and was abandoned in 1819 after
fourteen parts had been published.

Constable financed the production and publication of *English Landscape
Scenery* himself, perhaps wanting to embark on a new and different artistic
project after his wife Maria's death in 1829. As he wrote in his introductory
text to the 1833 edition: 'it originated in no mercenary views, but merely as

a pleasing professional occcupation, and was continued with a hope of imparting pleasure and instruction to others'. His title is significantly and typically much more down-to-earth than that of Turner's, and their different attitudes are clearly reflected in the title pages of each work (plates 94 and 95). While Constable's is in basic letterpress, Turner's title page is an elaborate combination of etching and mezzotint. The iconographical content of Turner's frontispiece is complex; Constable's consists only of the title of the book. The 1830 edition was titled *Various subjects of landscape, characteristic of English scenery, from pictures painted by John Constable R.A.*, while the 1833 edition added the words: *principally intended to mark the phenomena of the chiaroscuro in nature.* (His use of the term 'chiaroscuro' – Italian for 'light-dark' – while appropriate to many of his paintings is still rather surprising, but perhaps he was attempting to give his volume an intellectual tone that would appeal to more old-fashioned connoisseurs.) The format of Turner's frontispiece is similar to such earlier volumes as architectural treatises: there are various visual references to the subjects dealt with in the contents of the book. Here, for instance, fish and tackle denote marine subjects, plants and a basket of eggs refer to pastoral landscapes and, stress-

Plate 95.
Title page of *English Landscape Scenery*, 1833. Letterpress, approx 29.4 × 43 cms (11⅝ × 17⅛ ins).

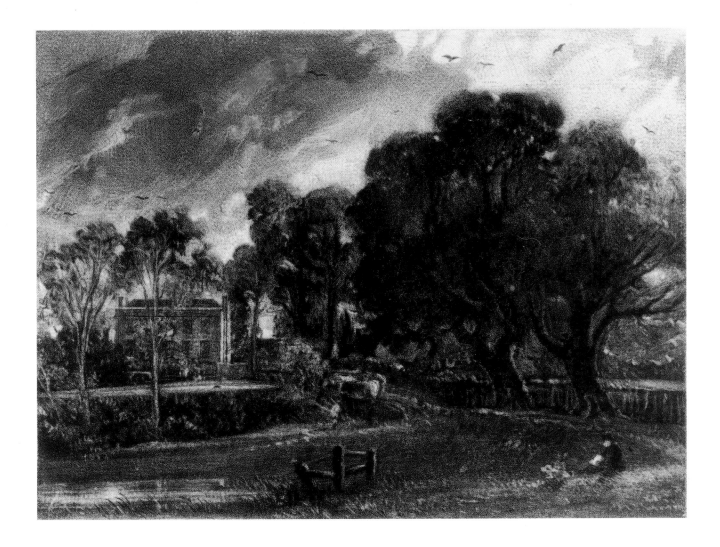

ing Turner's interest in classical antiquity, there is a massive piece of Ionic capital piled up next to a fragment of its entablature. The centre image, etched and mezzotinted entirely by Turner himself, shows the mythological subject of the rape by the god Jupiter of the princess Europa. In contrast, Constable's first visual image in *English Landscape Scenery* was of his late father's house (and his own birthplace) at East Bergholt in Suffolk (plate 96).

The first edition of *English Landscape Scenery* was published in 1830, the year after Constable had been elected a Royal Academician: like Turner he presumably wanted to mark this elevation of his artistic status. Also like Turner's *Liber*, however, *English Landscape Scenery* was not a commercial success. Improvements to the second edition, of 1833, included the expanded title and the addition of Constable's own commentaries to the plates.

Turner categorised his subjects in his *Liber* as Pastoral, Marine, Historical, and so on. His first plate was untitled but is now referred to simply as *Bridge and Cows*: it is in the Pastoral mode (plate 97). Constable's first plate is

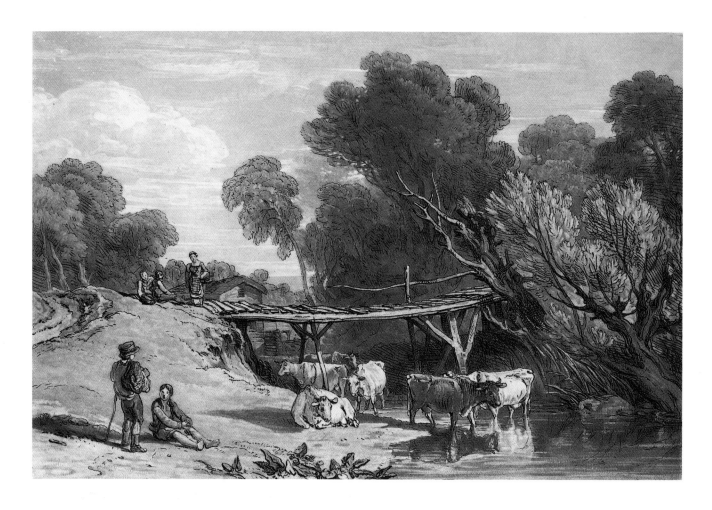

almost a naturalistic challenge to Turner, giving a specific location as the title: *East Bergholt, Suffolk; House and Grounds of the late Golding Constable, Esq.* The accompanying text provides a mixture of poetry, pictorial analysis ('in this plate the endeavour has been to give, by richness of Light and Shadow...the broad still lights of a Summer evening, with the solemn and far-extended shadows cast around by the intervening objects'), and personal reminiscence ('it was in scenes such as these...that the Author's ideas of Landscape were formed, and he dwells on the retrospect of those happy days...passed in the calm of an undisturbed congenial study, with a fondness and delight which must ever be...a source of happiness and contentment'). The subject, and to a certain extent the composition, are similar to those of Turner's plate, and may be considered a direct artistic challenge.

Although Constable's first idea for *English Landscape Scenery* was to publish images of his beloved Stour Valley, with a few selected views in Salisbury, Weymouth, Brighton and Hampstead, the presence of mezzotints after such large paintings as *Hadleigh Castle* suggests that Constable came to view the project as a comprehensive overview of his life's work to date, just as Turner had done. The plates record the range of Constable's achievement,

Plate 97.
Charles Turner A.R.A. (1774–1857) after J. M. W. Turner, *Bridge and Cows*, 1807. Etching and mezzotint (second state) printed in brown ink, 18.6 × 26.3 cms (7¼ × 10⅛ ins). Published in the first part of the *Liber*, the style is based on that of Thomas Gainsborough. The engraved 'P' could indicate the category of 'Pastoral' or 'Picturesque'. E.2718–1927

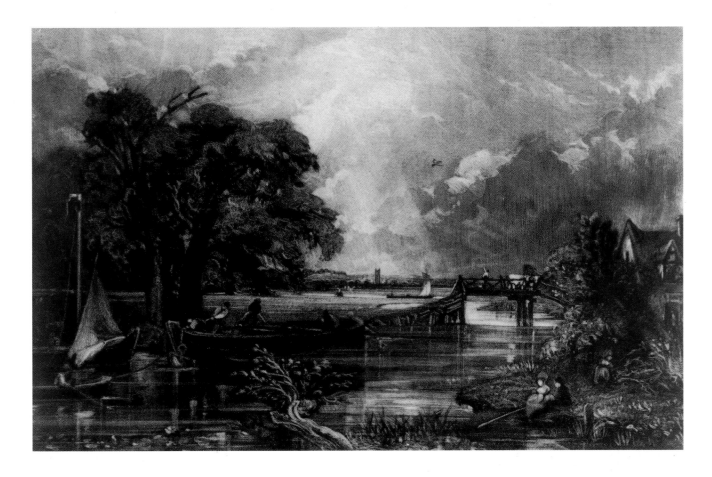

Plate 98.
Scene on the River Stour,
1831. Mezzotint,
approx 29.4 × 43 cms
(11⅝ × 17⅛ ins). This print
was first published in Part 4
of *English Landscape
Scenery*, in 1831.
The original painting was
exhibited at the R.A. in
1822, and is now in the
Huntington Museum, San
Marino; the full-size oil
sketch is in the collection of
Royal Holloway College,
London. It was the fourth
of the six large canal scenes
(Constable's 'six-footers'),
which included *The Hay
Wain* and *The Leaping
Horse*.
E.2417–1901
(in volume 95.G.3)

with engravings of elaborate and exhibited paintings such as *Scene on the River Stour* (plate 98) and *Hadleigh Castle* (plate 99), oil sketches such as *Spring* (plate 100) and *Stoke-by-Nayland, Suffolk* (plate 101), and even the great watercolour of *Old Sarum*.

Constable's introductory text began with lines from the poets James Thomson ('Oh, Nature! all sufficient! over all! Enrich me with the knowledge of thy works!') and Wordsworth ('O England! dearer far than life is dear'), and short quotations from Virgil and Ovid in Latin. Then Constable's own text, written in the third person, continues:

He conceives it to be in a just observation of natural scenery in its various aspects...The immediate aim of the Author in this publication is to increase the interest for, and promote the study of, the Rural Scenery of England, with all its endearing associations, its amenities, and even in its most simple localities...England, with the climate of more than vernal freshness, and in whose summer skies, and rich autumnal clouds, the observer of Nature may daily watch her endless varieties of effect...the subjects, consisting mostly of home scenery [that is, in Suffolk] are taken from real places.

The enterprise was not without its fair share of problems, as well as not being a commercial success. Constable constantly interfered, making changes to the mezzotinted images that Lucas had made, not only in detail but in

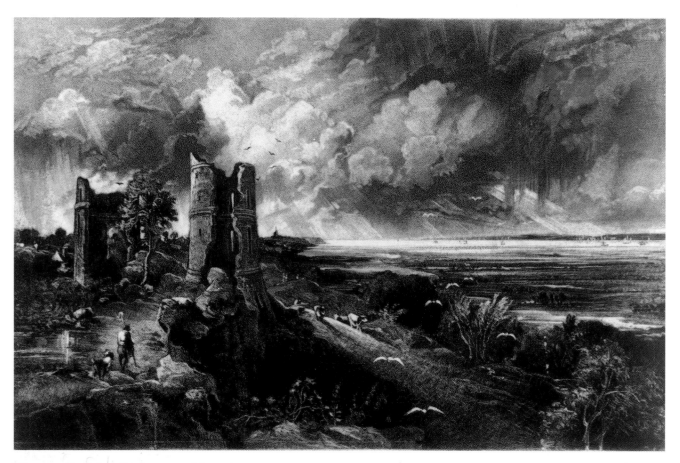

Plate 99. *Hadleigh Castle*, 1832. Mezzotint, approx 29.4 × 43 cms (11⅝ × 17⅛ ins).
This print was first published in Part 5 of *English Landscape Scenery*, in 1832.
The original painting was exhibited at the R.A. in 1829, and is now in the Yale Center
for British Art, New Haven; the full-size oil sketch is in the Tate Gallery.
E.2422–1901 (in volume 95.G.3)

Plate 100. (*opposite, top*) *Spring*, 1830. Mezzotint, approx 29.4 × 43 cms
(11⅝ × 17⅛ ins). This was first published in Part 1 of *English Landscape Scenery*, in
1830. The original oil sketch of about 1816 is in the V&A. The text begins – after a few
lines of quoted poetry: 'This plate may perhaps give some idea of one of those bright
and animated days of the early year, when all nature bears so exhilarating an aspect'.
E.2403–1901 (in volume 95.G.3)

Plate 101. (*opposite, bottom*) *Stoke-by-Nayland, Suffolk*, 1829–30. Mezzotint,
approx 29.4 × 43 cms (11⅝ × 17⅛ ins). Constable first made sketches of Stoke-by-
Nayland church in various media *c*.1810, returning to the subject twenty years later
in *English Landscape Scenery*. This print was first published in Part 2, in 1830.
He made an oil sketch now in the V&A (another is in the Tate Gallery) and five years
later painted a large finished oil painting, now in the Art Institute, Chicago.
E.2411–1901 (in volume 95.G.3)

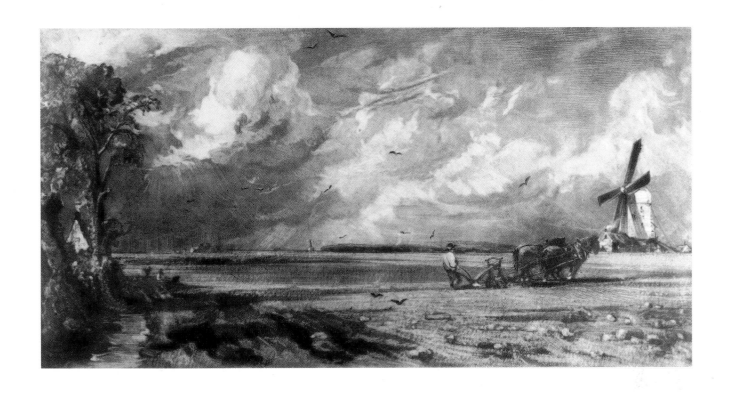

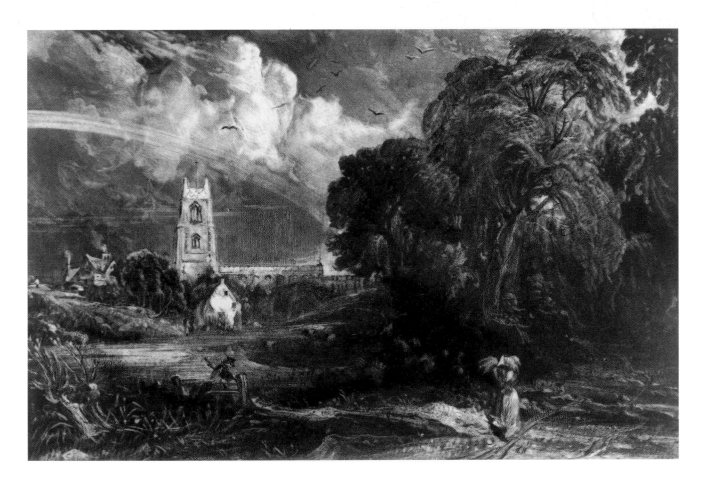

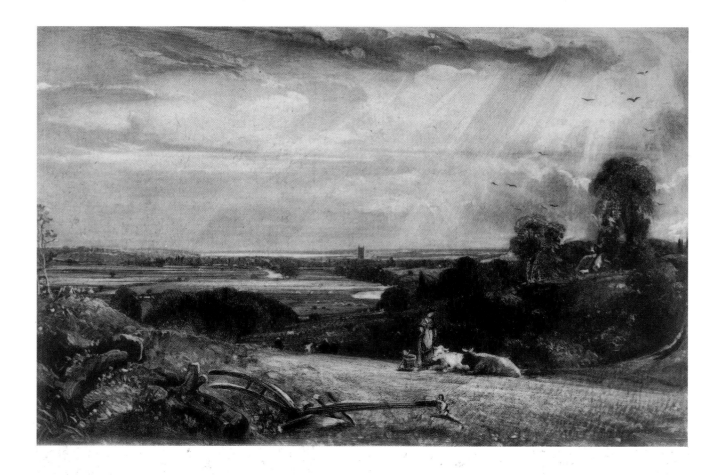

overall composition and atmospheric effect. In the end, however, the combination of Constable's vision and Lucas's technique could be seen as a triumph. It seems strange that Constable, relishing to such a great extent the physical quality of pigment – whether mixed with oil or water – should be so concerned with a series of mezzotints, however much they might promote his reputation. But Constable seems to have seen some inherent, and hitherto unexplored, possibilities of the mezzotint process, and to have pressed Lucas to experiment and persevere. On 5 May 1832, for example, he wrote to Lucas:

I am so sadly grieved at the proof you now send me of the Castle that I am most anxious to see you. Your art may have resources of which I know nothing – but so deplorably deficient in all feeling is the present state of the plate that I can suggest nothing at all – to me it is utterly, utterly hopeless...I am sadly distracted about my work – its emptying my pocket is the least evil.

As Beckett notes in his edition of Constable's correspondence, the relationship between Lucas and Constable was like that of 'two children who quarrel over nothing, say how sorry they are for what has happened, and then forget all about it'. It was a remarkable collaboration, as personal as it was professional.

Plate 102. *Summer morning*, 1831. Mezzotint, approx 29.4 × 43 cms (11⅝ × 17⅛ins). This print was first published in Part 3 of *English Landscape Scenery*, in 1831. The original oil sketch is in the V&A (plate 103). E.2407–1901 (in volume 95.G.3)

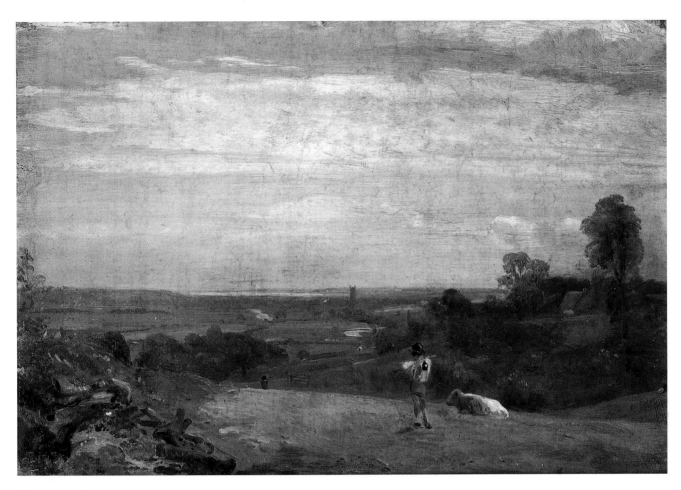

Plate 103. (*above*)
Summer morning: Dedham from Langham, c.1812.
Oil on canvas, 21.6 × 30.5 cms (8½ × 12 ins). This has been dated to about 1830 but was almost certainly painted much earlier. Constable asked Lucas to use this sketch for the mezzotint, but made several changes of detail: the figure of the boy in the foreground was replaced by a milkmaid and two cows, and he introduced a plough in the left foreground. The overall composition first appeared on a page of the 1813 sketchbook (plate 104).
132–1888 [R332]

Plate 104. (*right*)
Dedham Vale, 1813. Pencil, 8.9 × 12 cms (3½ × 4¾ ins). Inscribed by the artist bottom left 'Dedham from Langham'.
317–1888 [R121]

The personal quality of *English Landscape Scenery* was not limited to Constable's relationship with David Lucas. *Summer Morning* (plate 102) shows one of the artist's favourite views, looking from Langham village towards Dedham. In the accompanying text Constable wrote that the view of the 'beautiful Valley of the Stour...is taken from Langham an elevated spot to the N.W. of Dedham, where the elegance of the tower of Dedham church is seen to much advantage, being opposed to a branch of the sea at Harwich where this meandering river loses itself'.

The progress of this composition went through several phases, from an oil study dating from about 1812 (plate 103) and a pencil drawing in the 1813 sketchbook (plate 104) to the various states of the mezzotint itself. It is interesting that he never embarked on a full-scale oil painting of this marvellous view, although he made a medium-sized picture in the late 1820s; it is impossible to determine whether this is a sketch or an unfinished painting. Despite the many alterations in detail which Constable demanded of Lucas, the initial inspiration – the countryside of Suffolk itself – survived. In a letter to Lucas from Hampstead written towards the end of the project, on 14 November 1832, he refers to a coach journey from Suffolk. Sharing the coach 'were two gentlemen and myself all strangers to each other. In passing through the valley about Dedham, one of them remarked to me – on my saying it was beautiful – "Yes Sir – this is Constable's country!" I then told him who I was lest he should spoil it'.

Constable's propagation of his love of the Suffolk countryside may not have been a resounding popular success during his lifetime, but his legacy in the form of reproduction is considerable. Today there must be in existence millions of postcards, posters, calendars, table-mats, ceramic plates and so on, bearing images created by Constable.

CHAPTER 10
CONSTABLE AND HIS INFLUENCE

Early in 1832 Constable was bedridden with painful rheumatism. He wrote to C.R. Leslie, who was staying at Petworth House to study in Lord Egremont's splendid picture gallery, about the work of Claude, Hobbema and Thomas Gainsborough (1727–88), concluding his letter with these famous lines:

As to meeting you in these grand scenes, dear Leslie, remember the great were not made for me, nor I for the great, yet, perhaps, things are better as they are. My limited and abstracted art is to be found under every hedge, and in every lane, and therefore nobody thinks it worth picking up.

It seems extraordinary today that such a parochial artist as Constable, producing what he himself described as a 'limited and abstracted art to be found under every hedge, and in every lane', should have achieved fame and success abroad during his lifetime, and not have enjoyed equal recognition in his own country. At the same time, Turner, a great traveller here and abroad, received critical acclaim in London, but was all but unknown overseas. It is impossible to even suggest a reason for this art-historical phenomenon, but what little evidence exists surrounds the public display, first at the 1821 R.A. summer exhibition, of Constable's most famous painting: *The Hay Wain* (plate 105; see also plate 17).

Connections between the metropolitan art worlds of London and Paris had been disrupted, of course, by the French Revolution and the subsequent Napoleonic wars. During the temporary Peace of Amiens between Britain and France in 1802, however, several Royal Academicians seized the opportunity to travel to the Continent. Turner, for example, recently elected an Associate of the R.A., ended his own tour by visiting Paris to see the spectacular assembly of Old Master paintings in the Palace of the Louvre, looted by Napoleon during his campaigns and incorporated into what had been the royal collection of the kings of France. By contrast, in the same summer Constable had just abandoned his studies at the R.A. and returned home to Suffolk.

Constable's relationship with France's painters and dealers seems to divide into three overlapping phases. Firstly, there was his connection with the Paris dealers John Arrowsmith and Claude Schroth; then the admiration expressed by the painters Théodore Géricault (1791–1824) and Eugène Delacroix (1798–1863) as well as by the authors, writing as art critics, Stendhal (1783–1842) and Charles-Pierre Baudelaire (1821–67); and thirdly

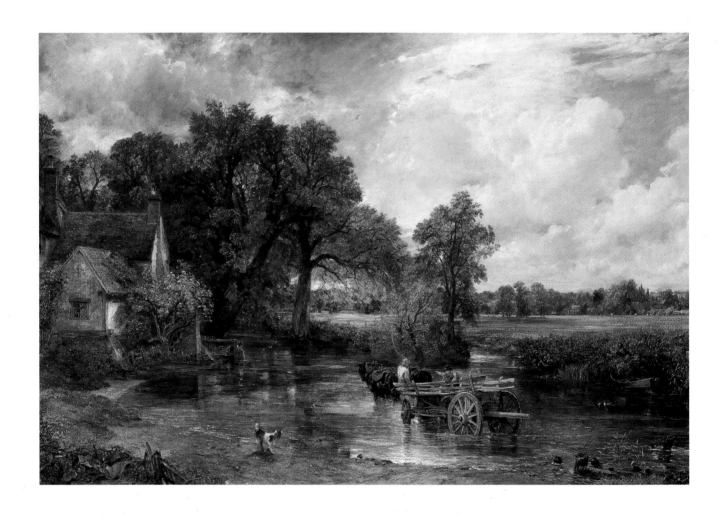

Plate 105. *The Hay Wain*, 1820–21. Exhibited at the R.A. 1821 (as *Landscape: Noon*), also at the British Institution 1822 and the Paris Salon 1824–25. Oil on canvas, 130.5 × 185.5 cms (51¼ × 73 ins). Inscribed by the artist along the bottom 'John Constable pinxt.London 1821'. National Gallery (1207)

the effect his paintings had on the development of landscape painting in France for over fifty years, through the Barbizon School to Impressionism.

Despite his name, the Paris art dealer John Arrowsmith was a Frenchman whose parents or grandparents presumably had emigrated from England at some time. Little is known of him until he visited London in the spring of 1822, with the particular intent of looking at the contemporary English paintings on exhibition at the British Institution. One of the principal pictures on display was Constable's *Landscape: Noon – The Hay Wain*. It had been shown, but not sold, at the R.A. the previous year; the price now was £157 10s. Constable wrote to Fisher on 13 April:

I have had some nibbles at my large picture [*The Hay Wain*] at the Gallery. I have had a <u>professional</u> offer of £70 for it (without the frame) to form part of an exhibition in Paris – to show them the nature of the English art. I hardly know what to do – it may promote my fame and procure commissions, but it may not. It is property to my family – though I want the money dreadfully.

He wrote again on 17 April to say that he had decided against selling the picture to Arrowsmith: 'It is too bad to allow myself to be knocked down by a Frenchman. In short it would fetch my family something one time or another and it would be disgracing my [RA] diploma to take so small a price and less by over one half than I asked.'

Arrowsmith visited London again very early in 1824, and on 17 January Constable wrote to Fisher again:

The Frenchman who was after my large picture of the Hay Cart last year is here about it again – he would I believe have both that and the Bridge [the *View on the Stour, near Dedham*, now in the Huntington Art Gallery, San Marino, USA] if he could have them both at his own price. He has made me offers for that one or both…His object is to make a show of them in Paris, perhaps to my advantage – for a prophet is not known in his own country…He most desires that as it has already a great reputation at Paris…<u>He</u> assures me that it will become the property of the French nation – and will be in the Louvre the ensuing exhibition…

He sold the two paintings to Arrowsmith for £250, writing to Fisher on 8 May that they 'cannot fail of melting the stony hearts of the French painters. Think of the lovely valleys mid the peaceful farmhouses of Suffolk, forming a scene of exhibition to amuse the gay and frivolous Parisians'.

In his second lecture at the Royal Institution, 'The Establishment of Landscape' given on 2 June 1836, Constable expanded on this matter. In

what was a rather rambling and certainly Francophobic script, he began by praising the Bolognese school, singling out the work of the Carracci family and Domenichino (1581–1641), the 'Franco-Roman' school of Poussin and Claude Lorrain, and certain Dutch and Flemish landscape painters of the seventeenth century, before homing in on the decline of French art in the eighteenth century. He prefaced his anti-French diatribe by condemning the landscape painters Jacob More (c.1740–93), Philip Hackert (1737–1807) and John Wootton (c.1678–1764), who 'still further debased' the art of landscape painting. In Constable's words, the 'climax of absurdity to which the art [of landscape painting] may be carried…away from nature by fashion may best be seen in the works of Boucher'. His description of François Boucher (1703–70), continued thus:

His landscape, of which he was evidently fond, is pastoral; and such pastorality! the pastoral of the Opera House. But at this time, it must be remembered, the court were in the habit of dispersing into the country, and duchesses were to be seen performing the parts of shepherdesses, milk maids, and dairy maids…His scenery is a bewildered dream of the picturesque. From cottages adorned with festoons of ivy, sparrow pots etc. are seen issuing opera dancers with mops, brooms, milk pails and guitars…Boucher told Sir Joshua Reynolds that 'he never painted from the life, for that nature put him out'.

Another dealer in Paris, Claude Schroth, was also impressed by Constable's work, and ordered three Hampstead views. As Arrowsmith also bought more, so Constable had accumulated nearly £600, and no fewer than twelve paintings went to Paris. Fisher wanted Constable himself to go, to make what we would call today 'a personal appearance', writing on 10 May: 'We now <u>must</u> go there for a week'. But Constable's wife Maria was ill, and in any case he was loath to leave England – particularly to visit France.

Despite his refusal to promote himself, Constable's work became immensely popular in Paris and in turn French visitors poured into his London studio. Delacroix visited Arrowsmith's Paris gallery, and recorded in his journal on 19 June 1824: 'Saw the Constables…That Constable did me a great deal of good'. This 'great deal of good' was visually expressed in the repainting of the background of his 1824 *Massacre de Scio* (now in the Louvre) and, particularly, the backgrounds of his 1826 *Portrait of Baron Schwiter* (now in the National Gallery) and the 1827 *Still-life with Lobsters* (also now in the Louvre), both of which could almost have been painted by

Constable himself. The landscape background of the still-life is very like Constable's Hampstead Heath painting bought by Schroth in 1824, and presumably seen by Delacroix in Paris. Delacroix had already recorded in his journal on 9 November 1823 that he 'saw the Constable sketch for the second time – admirable, quite incredibly fine'. Delacroix's enthusiasm for Constable was probably ignited by Géricault, an older fellow student in the studio of Baron Pierre-Narcisse Guérin (1774–1833). An extremely controversial painter during all of his short career, Géricault seems to have been very impressed by *The Hay Wain*, exhibited at the 1821 R.A. exhibition during his two-year stay in London.

Before and during the negotiations with Arrowsmith and Schroth, other French critics had noticed Constable's work. Charles Nodier, for example, wrote in his journal *Promenade de Dieppe aux Montagnes d'Ecosse* (published in France in 1821) that he thought *The Hay Wain* was the best painting in the R.A.'s 1821 exhibition. The great French writer Stendhal, writing a series of eight articles about the Paris Salon of 1824 at which *The Hay Wain* was exhibited, disliked the work of Sir Thomas Lawrence – 'the top London portrait painter is pretty mediocre' – but wrote that:

on the other hand the English have sent us some magnificent landscapes this year by Monsieur Constable. I doubt if we have anything to compare with them. The truth of these charming works instantly strikes and delights us. Monsieur Constable's brushwork is excessively free, and the planes of his pictures are carelessly observed. He has no ideal, but his delightful landscape with the dog on the left is the mirror of nature, and it completely outshines a large landscape by Monsieur Watelet hanging next to it in the main gallery.

In the next paragraph of this article, headed with the title 'Classical versus Naturalist Landscape', Stendhal describes the trees of the classical school as having 'a style and elegance, but lack truth. Constable, on the other hand, is as truthful as a mirror, but I wish that this mirror reflected a magnificent place such as the valley of the Grande Chartreuse near Grenoble, and not a hay cart crossing a canal of stagnant water'.

Like that of many of his contemporaries in France and England, Stendhal's opinion of Constable's work is divided into admiration for his fresh naturalism and dismay for his apparent lack of interest in both classical structure and 'important' subject matter. But it was exactly Constable's personal and open-air approach to landscape and his spontaneous handling of pigment

that were to contribute to the development of nineteenth-century landscape painting, especially in France. A direct line can be traced from Delacroix's adoption of Constable's vibrant and contrasting colours, applied in small liquid strokes of the loaded brush, in dry (usually white) 'scumbling' where the brush is lightly dragged across the painted surface, and in thick areas of impasto, to the painters of the Barbizon School. Taking its name from the village of Barbizon in the Forest of Fontainebleau, some thirty miles from Paris, it was led by Jean-François Millet (1814–75), Théodore Rousseau (1812–67) and Narcisse Virgil Diaz de la Pena (1808–76). Like Constable, they wanted to paint as much as possible in the open air, depicting real places as they actually were, rather than attempting to render the scenes 'Picturesque' or classical.

Millet's character and career in particular were very similar to those of Constable. He was born in rural Normandy, and eventually studied painting in Paris. He moved to Barbizon in 1849, and stayed there for the rest of his life painting scenes of peasant life. Like Constable, he painted people working, but unlike Constable he often made the figures dominate the landscape (plate 106). He considered Barbizon a civilized refuge from the dissolute luxury of city life. His great friend Rousseau was born in Paris, but began painting in the open air in the countryside around the city in the later 1820s. Again, like Constable at the R.A., Rousseau found that the bright naturalism and simple subject-matter of his paintings were rejected by the Paris Salon, and indeed he acquired the nickname 'Le Grand Refusé'. Several of his landscapes are similar to those of Constable (plates 107 and 108). It is the work of the Barbizon School that provides the backcloth to the first wave of French Impressionism. The closest link is with Charles François Daubigny (1817–78), who visited England, also spent much time in Barbizon, and was much admired by Claude Monet (1840–1926). He habitually painted out-of-doors, even large canvasses, and built a studio-hut on a rowing boat in which he painted views on the River Oise, a device Constable would surely have envied. Monet, Alfred Sisley (1839–99), Pierre August Renoir (1841–1919) – who studied together in Paris – Camille Pissarro (1830–1903) and Paul Cézanne (1839–1906) all worked in the countryside rather than in the studio, sometimes in Barbizon or elsewhere in Fontainebleau.

Perhaps the end of this line is reached in the 1880s with both the pointillism of Georges Seurat (1859–91), who used tiny dots of colour to achieve a

Plate 106.
Jean-François Millet
(1814–75),
The Wood-Sawyers,
c.1850–52.
Oil on canvas,
57 × 81 cms
(22½ × 32 ins).
CAI 47

blended optical effect and had looked closely at the work of Delacroix, and with the expressionism of Vincent Van Gogh (1853–90). Both artists shared with Constable an interest in the direct and physical act of applying paint with a brush on to a canvas, and breaking down colours into various components to give a shimmering optical effect. It is interesting that Turner's work seems to have had very little comparable effect. Often referred to as a 'proto-Impressionist', Turner and his work were practically unknown to French artists until Monet and Pissarro came to London in 1870. (The first work by Turner to enter the Louvre collection was acquired as recently as 1967.) In 1866, the art critic P. G. Hamerton wrote that Constable 'did not see lines, but spaces, and in the spaces he did not see simple gradations, but an immense variety of differently coloured sparkles and spots. This variety really exists in nature, and Constable first directed attention to it'. He continued: 'all the best modern French landscape is due to the hints he gave. That landscape is now the most influential in Europe'. This was later published in Hamerton's *Thoughts about Art* of 1873.

Back in England, it took some years for Constable's work to be fully appreciated. He had written to Fisher early in 1821 that 'I now fear...I shall never

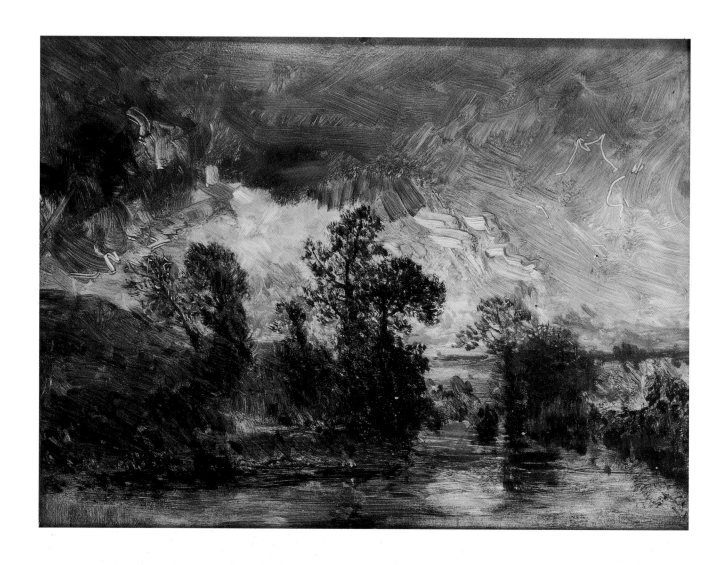

Plate 107. Pierre Etienne Théodore Rousseau (1812–67), *Landscape with a stormy sky*, *c*.1842. Oil on millboard, 24.8 × 35.2 cms (9¾ × 13⅞ ins). CAI 55

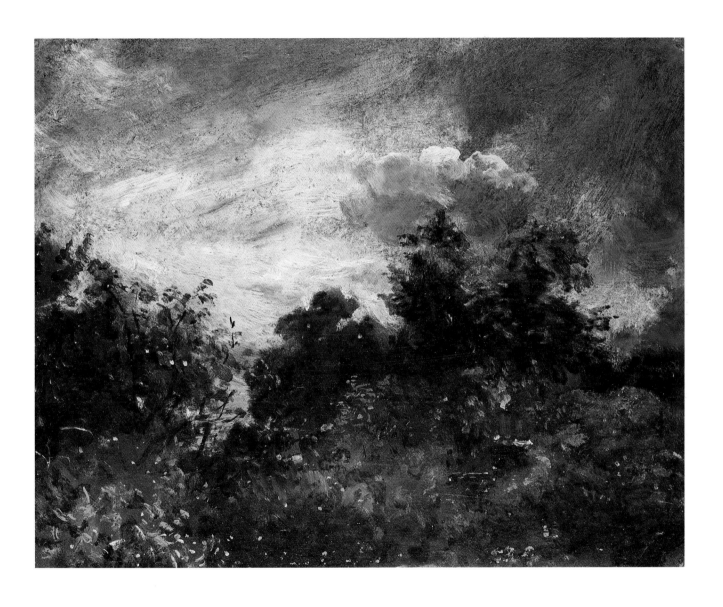

Plate 108. *Study of sky and trees*, c.1821. Oil on paper, 24.1 × 29.8 cms (9½ × 11¾ ins).
Inscribed by the artist on the back 'September 3d. Noon. very sultry. with large drops of
rain falling on my palate light air from S.W.' 151–1888 [R221]

be a popular artist', and for many years his self-appraisal was correct. The critical acclaim he received in Paris and London in the early 1820s was short-lived, and his paintings achieved, at most, grudging approval. Most of his paintings and drawings remained in the care of his family after his death. The six studio auction sales at Foster's in 1838 of his collection of Old Master prints and drawings, and of his own work, were not a great success. Constable's paintings were either unsold or fetched very low prices. But the longer-term result of the sales was dramatic: for one thing, it must have been the first time Constable's oil sketches had been seen in public.

The other immediate source of information about Constable, and the principal reason for Constable's posthumous fame apart from the paintings themselves, was C.R. Leslie's *Memoirs of the Life of John Constable*. Completed in 1842, first published in 1843, followed by a second edition in 1845 and then eight further editions, its success accompanied the increasing interest in the 1840s in modern British paintings, including works by Constable, which was encouraged by the establishment of the *Art Journal*. Before long, his work was being copied and forged, with several of his oil sketches 'finished' to look like exhibited paintings. Paintings 'in the manner of Constable' appeared on the art market. Constable's work – original or not – was now considered worth collecting. As genuine Constables came up in the salerooms, their prices gradually increased.

During Constable's lifetime, however, his artistic influence was limited to his immediate circle of friends: George Frost, John Dunthorne senior, Archdeacon John Fisher, and his studio assistant John Dunthorne junior, all of whose works have been confused with those of Constable himself. For example, the now famous oil sketch *Plants growing near a wall*, from the Isabel Constable bequest of 1888 (plate 109), has been re-attributed to Dunthorne junior, a suggestion that is very supportable. Outside this immediate circle, the leading artist who worked in the style of Constable was Frederick Waters Watts (1800–70); he painted many views in Hampstead, where he lived all his working life, and copied Constable's *Cornfield* and *The Leaping Horse*. He also painted several views on the River Stour, which in composition as well as handling are very like Constable's famous views, although it seems Watts never actually visited Suffolk. Again, these are often confused with the work of Constable. The only oil by Watts in the V&A collection is *On the Wye*, another of the artist's favourite subjects.

Although not as close to Constable as many of his paintings, it shares the same handling of paint, treatment of light and atmosphere, and softly bucolic mood (plate 110). Other imitators were William George Jennings (1763–1854), who bought a Constable view of Hampstead Heath and himself made oil sketches of Hampstead; the amateur painter George Constable (1792–1878), who was no relation to John but was a friend; Thomas Churchyard (1798–1865), also an amateur who owned and copied John's work; and James Webb (1825–95), accused after his death of actually forging Constable's work although it seems more likely that he was simply an honest imitator.

Several of Constable's descendants were artists, inevitably following to various extents their distinguished ancestor's achievements. In Ipswich in 1954 there was an exhibition of the work of no less than five generations

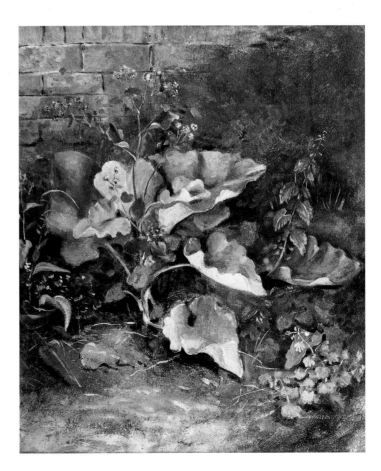

Plate 109.
*Plants growing near a wall, c.*1820–30.
Oil on paper,
30.5 × 24.8 cms
(12 × 9¾ ins).
785–1888 [R325]

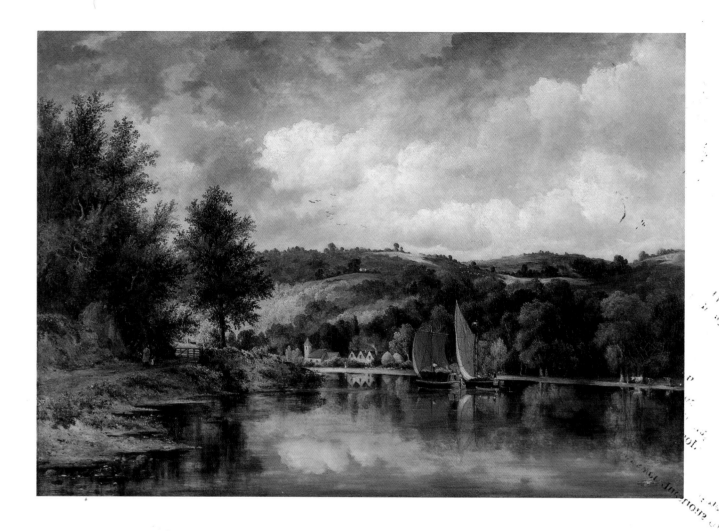

of the Constable family. John and Maria's last born child, Lionel Bicknell Constable (1828–87), was probably the closest and most loyal follower, making, for example, a sketchbook in 1847 recording places such as Osmington and Weymouth Bay which his father had visited over thirty years before.

But Constable's influence spread more widely than among his immediate acquaintance and family. It was his work that encouraged European landscape painting of the second half of the nineteenth century to turn in the direction of attempted realism and truth to nature, especially in the practice of painting landscapes on the spot – out-of-doors in the open air – rather than in the confines of the studio. He was also influential in the expansion of the colours on the palette, and the greater freedom of handling with the paintbrush. The eighteenth-century desire of landscape artists to make their pictures look like the work of continental European Old Masters and to capture a lost Arcadia inhabited by gods and goddesses, happy shepherds and shepherdesses, contented peasants and farmworkers, yielded to a wish to show (as in the title of John Barrell's memorable and important book)

Plate 110.
Frederick Waters Watts
(1800–70), *On the Wye*,
1830s. Oil on canvas,
85.1 × 118.4 cms
(33½ × 46½ ins).
262–1866

the 'dark side of the landscape'. The plight of the rural poor, reflecting the poverty of the new industrial towns and cities, the flight from an agricultural life to work in the new factories, the might of the great centres of commerce such as Manchester and London: all became subjects for artists. Sometimes polemical, sometimes sentimental, these images of everyday life owe a great deal to Constable's depictions of work going on in Suffolk, Hampstead and along the beaches of the Sussex coast. What he modestly called his 'limited art', 'to be found under every hedge and in every lane', was perhaps the most revolutionary of the century in England (plate 111).

His influence survived another important artistic revolution – the cubism of the French painter Georges Braque (1882–1963) and Spanish-born Pablo Picasso – and continues today, seen in the work of thousands of amateur artists all over the country. Reproductions of his pictures can be found in thousands of homes. Most of all, his abiding legacy has been our attitude today towards the English countryside: nostalgic maybe in a post-industrial world, but in the years around 2000 nonetheless still real and meaningful.

Plate 111.
Studies of plants at Fittleworth Mill, Sussex, 1834. Pencil and water-colour, 20.6 × 27.2 cms (8⅛ × 10¾ ins).
Inscribed by the artist top left 'Fittelworth Mill 1834 23 Sep'.
215–1888 [R370a]

FURTHER READING

The standard catalogue of Constable's works in the V&A is by Graham Reynolds, first published in 1960, and in a revised edition in 1973.

R. B. Beckett, ed, *John Constable's Correspondence*, 6 vols, 1962–1968 (Suffolk Records Society).

Judy Crosby Ivy, *Constable and the Critics 1802–1837*, 1991 (Suffolk Records Society and the Boydell Press).

C. R. Leslie, *Memoirs of the life of John Constable, composed chiefly of his letters*, ed. Jonathan Mayne. First published 1951, with various later editions.

Leslie Parris and Ian Fleming-Williams, *Constable*, catalogue of the Tate Gallery exhibition, 1991 (Tate Gallery Publications).

Graham Reynolds, *Constable the Natural Painter*, first published 1965. Various later editions.

Graham Reynolds, *The Earlier Paintings and Drawings of John Constable*, 2 vols, 1996 (Yale University Press).

Graham Reynolds, *The Later Paintings and Drawings of John Constable*, 2 vols, 1984 (Yale University Press).

Michael Rosenthal, *Constable: the painter and his landscape*, first published 1983. Various later reprints (Yale University Press).

INDEX

Note: Figures in italics denote illustrations, and are page numbers rather than plate numbers. Constable's works are under generalised headings (eg Hampstead, Suffolk, trees etc.)